creative JOLT INSPIRATIONS

Visit our Web site at www.howdesign.com for more resources for graphic designers.

05 04 03 02 01 5 4 3 2 1

Library of Congress Cataloging-in-Publication Data

Gonnella, Rose.
 Creative jolt inspirations / Rose Gonnella, Denise M. Anderson, Robin Landa.—1st. ed.
 p. cm.
 Includes index.
 ISBN 1-58180-012-6 (pbk. : alk. paper)
 1. Commercial art—United States. 2. Graphic arts—United States. I. Anderson, Denise M. II. Landa, Robin. III. Title.

NC998.5.A1 G63 2000
741.6—dc21 00-056251

editors: lynn haller and linda hwang
design/production: dma
art director: denise m. anderson
designers: denise m. anderson, rose gonnella and robin landa
design assistants: laura menza, alejandro medina, cesar rubin, kathryn schlesinger, jenny calderon and bran bogdanovic
production coordinator: emily gross
cover concept: robin landa
cover art credits: © Cahan & Associates; Greg Leshé © 1997; © Alejandro Medina; © Kristine Philipps; © Nicole Roth; © Jennifer Sterling Design.

The copyright notices on pages 142–143 constitute an extension of this copyright page.

Creativity experts have said that greatness can only flourish amidst greatness. Think of the Renaissance and Modern art periods. Think of the time period of the visual communications pioneers. Witness the creative work in this book and you must agree that our time allows brilliance and creativity to flourish. This book is, in part, dedicated to the creative professionals who are leading the visual way.

To Petrula Vrontikis and Russell Hassell, whose inspirational materials led us to conceiving this book, we give special acknowledgment. What Russell and Petrula made us see was that many creatives go outside of their own visual arena to find inspiration.

Without the wonderful creatives in this book, there would be no book. They are listed in the credits and we bow to their talent.

Special thanks to Jilda Morera whose commissioned photography enabled us to create delicious juxtapositions, and photographer Jordi Cabré, who allowed us to sift through his life's work and scoop up as much as we wanted. Also to Philip B. Meggs, whose brilliant insights are an inspiration to us all.

Great thanks to the fine staff of DMA—Laura Menza, Alejandro Medina, Cesar Rubin, Shana Acosta, Kathryn Schlesinger, Jenny Calderon and Bran Bogdanovic—for their design assistance and tireless research. Thanks to Paula Bosco for help with the index.

Much thanks to the ace team at North Light Books: Lynn Haller, Linda Hwang and Claire Finney.

On a more personal note...

Rose thanks her wonderful Mom, Josephine, and Dad, Joseph, who are terrifically supportive of their "kooky" daughter even though she should call more often so that they know she hasn't fallen off the earth. She thanks her many students who are constant fountains of playful inspiration. And she thanks Franco, because everyone needs a loving muse.

Denise thanks her loving and supportive parents, family, friends and poodles for giving her a safe haven to return to when she needed to venture into the wild and unknown. She thanks her two former college professors, Robin Landa and Rose Gonnella, as well as her past students, especially Suzanne Peters, Jennifer Harold and Laura Menza, who continuously challenge and keep pure her love of design. Thanks to all the kids in Denise's life who nurture the "big, little kid" that she is. A very special thanks to Paula, who inspires Denise with a "new song" and a new "law term" everyday. Thanks to the DMA staff and clients who help inspire Denise to have a creative daily life where design never feels like work.

Robin thanks her divine husband and brilliant personal physician, Dr. Harry Gruenspan, and their darling daughter, Princess Hayley Meredith. Muchas gracias to sweet Linda Freire who took loving care of Hayley while Mommy worked on this book, and thanks to her dear family, Edmundo, Michelle and Cynthia Alcantara. *Robin dedicates this book to precious Hayley Meredith.* Hayley's world of children's books by such talents as Jan Pieńkowski and David Carter and the graphics on *Sesame Street* have provided a new resource of inspiration for Mommy.

table of contents

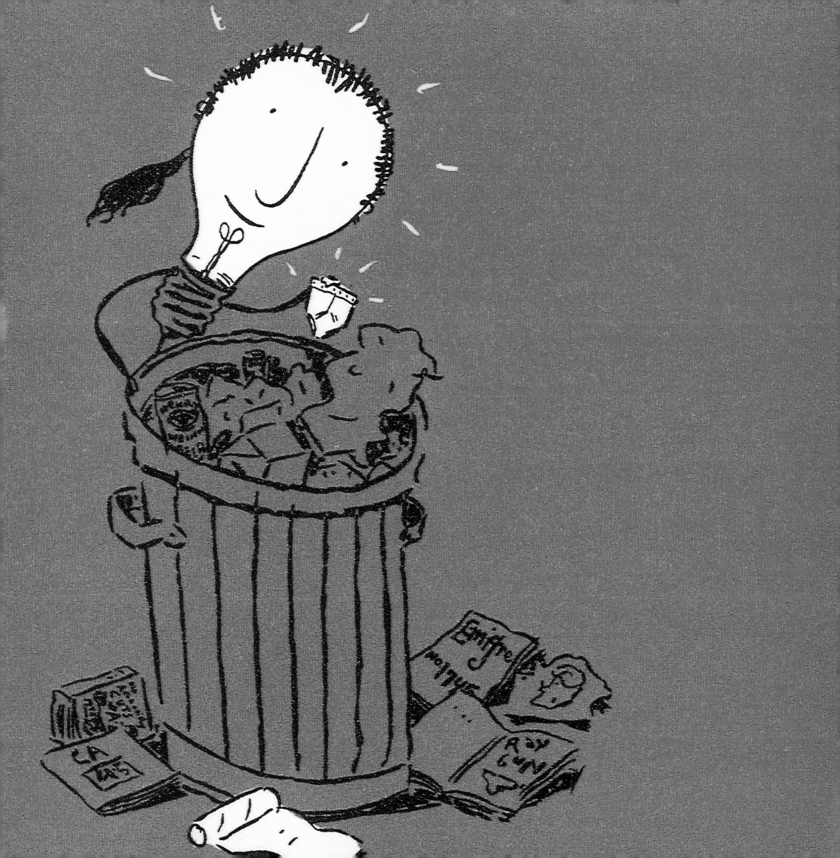

introduction

"much of my creative inspiration comes from garbage. when i'm in san francisco,
i spend friday evenings going through the dumpsters behind kit hinrichs's,
michael vanderbyl's and barry deutsch's studios. when i'm in new york, there's
a lot of great stuff to be found in james victore's garbage."

ric tharp

inspiration: a special influence or any stimulus to creative thought or action.

Creativity certainly does not occur in a vacuum. Our imaginations engage only after they have been filled with stimuli. Like a chugging and humming motor, our creative centers need a constant jolt of intellectual or emotional electricity to begin operating and to continue running smoothly. Imaginations are also like the trees, stretching out to gather light energy in order to not just grow, but to flourish.

self-ignite

An original creative act or response can erupt if the mind has been previously packed full of aesthetic fuel. Once the imagination has been intellectually charged, illuminated, supplied with a myriad of resources and blanketed with visual and conceptual ideas, it will self-ignite. It might be said that creativity is the result of spontaneous combustion. The combustible material (the brain) gets fired through the dynamic energy of its constituents.

Therefore, you must stockpile imagery and ideas. Inspiring visuals are rarely used at the moment of first discovery. Instead, they become part of your creativity storehouse. The materials and images pile onto one another in your brain. All those inspiring resources are compressed in your imagination. The pressure created by the demand for a visual solution to a communication problem causes a rumble in your stockpile. Deep inside the compressed layers of stimuli a "chemical" action takes place—that action is a need for a creative solution to a visual communication problem. The imagination rumbles until—BAM!—the stored images, ideas, information spontaneously combust. A creative idea is born. Petrula Vrontikis, a wonderfully inventive designer from Los Angeles, whose imagination is layered with imagery from her travels and adventures, has said, "Only a novice refers to the work of other designers as a resource when looking for creative stimulus. Experienced designers pull from everything else." With a heap of visual and conceptual stimuli stockpiled, solutions can pop almost instantaneously.

Artists often refer to a moment of epiphany—where an image would appear to them all at once. In reference to the painting, *The Shelton with Sun Spots* (1926), artist Georgia O'Keeffe stated: "I made that painting beginning at the upper left and went off the lower right without ever going back."

During a public lecture, a well-known designer stated that he would jiggle the solution from his imagination during the initial phone call with the client. Another would do the same as he scribbled on a napkin over a business lunch. Neither would take the job unless they had the solution to the problem by the end of the conversation with the client.

These creatives are highly practiced in their mediums. They also have a visual storehouse within their brains that is in all likelihood bursting at the seams.

previous image: **ward schumaker, illustrator,** "ric tharp in garbage can"

ivan chermayeff, graphic designer, "man in uniform"

fill 'er up!

The purpose of this book is not so much to scout for solutions, but a place to gather stimulating visual resources. It provides starting points to create or add to your own imagination's idea files.

By definition, inspiration is dynamic. The word is defined as "the action or power of moving the intellect or emotions; the act of drawing in"; to inspire is "to exert an animating, enlivening or exalting influence on; to draw forth or bring out." (*Webster's Tenth*).

You must actively seek. Search. Hunt. Wander. Skip. Pounce. Run. Chase. Look at everything. Travel. Or at least go for a walk. Use books to visit faraway places if you can't travel. Exert yourself in the pursuit of inspiration. Don't just sit there—unless, of course, you are reading.

Store the fruits of your inspiration gathering. Fill your imagination's storehouse. Draw upon what you've seen.

We hope you use our book as a starting point for gathering and filling your imagination stockpile. Perhaps if you are made aware of the quirky fabric of the 1950s you'll be compelled to visit a shop that sells antique fabrics (try the one in Newport, Rhode Island). Or, through this book, you'll note that a new palette of colors doesn't necessarily have to come from a swatch book—nature has the best palettes; go exploring among the Northwest coast tide pools.

Sayles's interest in design from the thirties and forties is reflected in his free-time activities and his personal life. A passionate collector of streamlined art deco and moderne artifacts, his home and studio are filled with pieces from his collection of furniture, accessories and fixtures, giving new life to the old adage, "Life imitates art."

An elegant setting filled with art deco furniture and artifacts—Sheree Clark's living room—and John Sayles in his vintage bathrobe are the inspirations for the poster promoting the Miami Modernism Art and Design show.

Since early in his career, designer John Sayles has admired the work of midcentury industrial designers such as Raymond Loewy, Donald Deskey, Russel Wright, Norman Bel Geddes and others—so much so that he began collecting objects designed by these legends. Sayles's burgeoning collection includes vintage furnishings, home accessories and art, and each item has inspired Sayles's own bold, streamlined design style.

Sayles's business partner, Sheree Clark, also is passionate about deco-era design. While Sayles's home is in the 1950s Danish Modern style, Clark lives in a 1939 blonde brick house that looks like it hasn't set foot in the latter half of this century. Both Sayles and Clark make the most of their nontraditional style and use it as a promotional tool to set their firm apart from their competition.

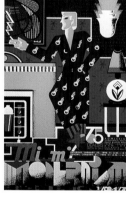

john sayles, graphic designer
left: "miami modernism" inspiration
top: "miami modernism"

"all the contributors have a unique vision and form of expression, in context with our hopeful world in which there is room for all of us, and our views."
carlos segura

search and synthesize

This is a book with several purposes. It is an idea file, a motivational sourcebook, a visual cookie jar. And, it is a peek inside the scrapbooks of artistic individuals.

First, we've gathered the details of creative projects and presented them out of context. Through details you may gain a better awareness of how the whole originated. End products are not so important in this book. Our intent is to show the way in which others see, think and are inspired. The interests of these creative individuals are an invitation to expand your own aesthetic sensibility.

Second, we present in isolation a glimpse at the media and techniques of designers and artists. Sometimes a single brushstroke may lead to a profound visual idea.

Third, we thought it would be fascinating to gather together some raw materials from the

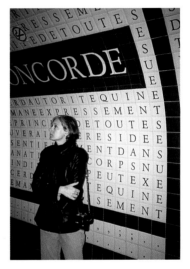

"One of the hardest things for a graphic designer to do is to avoid being influenced by other graphic design. A stop at the Concorde metro station in Paris rekindled my interest in pure typography, not only as a communications device, but as decoration as well. The entire underground station is surfaced with 4-inch tiles, each with an individual letter on it, surrounding a solid "box" with the station name in it. In the last year I have unconsciously used this same concept a number of times. The most recent was the design of placemats for a seafood restaurant."

ric tharp, graphic designer
top, left: "steamer's grillhouse placemats"
top, right: "steamer's grillhouse placemats" inspiration

scrap files of artists and designers and to present them purely in their unadapted state—interesting visual stuff. It is more important to note the avenues these individuals chose in search of stimulation than the objects themselves. Although the visuals in this book are inspiring, the purpose is not to copy them (Please don't. We promised the contributors you wouldn't.), but to use them as a springboard for your own search and gathering forays.

Finally, we've asked a group of creative individuals to share the inspiration for specific projects. Through these "case studies" you'll note that inspiration happens in the most unexpected ways. Don't underestimate the power of your grandmother's spaghetti colander (see page 136).

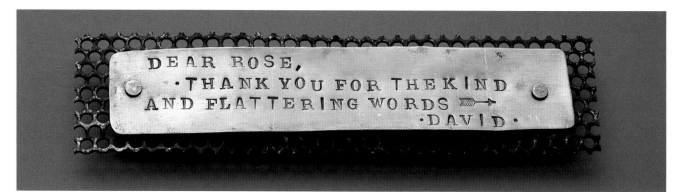

david walsh, sculptor, "thank you note"

cross over

We've included several nationally respected and exhibited artists in this book because, although they do not create for a specific client, their inspiration process is much the same as a designer's: a search, an open mind ready to gather visuals for later use, and a desire to draw from the world environment.

As design moves out of its history of purely "commercialism" into a contemporary milieu that is recognizing design with aesthetic appreciation, the line between fine art and design is becoming increasingly blurred. The fine arts and visual communications mediums crisscross when the designer creates a piece for himself without a client, such as Ivan Chermayeff's work in collage. Or, when a designer, art director or illustrator takes a creative leap, rather than merely answering the client's needs. The line between fine arts and visual communications disappears when a designer is able to convince a client that a design has a social and political conscientiousness. In the words of designer Stefan Sagmeister, design is art when it "touches someone's heart." Conversely, when an artist accepts a commission to paint a requested image or exhibits and sells, he or she has crossed into the realm of dependency on the public interest. Both the designer and the artist are professional. Each is valuable in terms of the contributions made to the cultural artifacts of our time.

"design begins in discovery.

"what's wonderful about design is that it's not something we must dream up; it is the look of the world we live in. it is not a facade but a portrayal of reality, a form beautifully and exactly expressing a function. our visual journey begins by looking at real things. what's to see? there are physical properties (shapes, colors, textures), and hidden intangibles (history, tradition, character). imagine! the subject will unfold layer by layer. this is where we fill our visual reservoir!"
john mcwade, designer and publisher of *before & after*

juxtapose

We love the philosophy of this excerpt from a popular 1930s swing lyric—

'T ain't what you do it's the way that you do it.

sy oliver & trummy young

Throughout the book we suggest ways to connect images, textures, colors and patterns and create stimulating interactions and juxtapositions. Our suggestions show that it is not so much what you find but how you relate your sources to each other.

Meaning comes from relationships. Through comparison we define the world around us. Think about scale: we only see something as small or large in relation to something else. An oak is large relative to a daisy but small in comparison to the ocean. Day is meaningful in relation to night. Now expand: What do raspberries have to do with women's shoes? What does a nautilus shell have to do with a human ear or a calla lily? Juxtapositions makes us see things anew. Comparing forms creates visual poetry. It's only from relationships that we draw meaning.

being a creative thinker

kris philipps, painter and printmaker
top: "noonday number two" inspiration
right: "noonday number two"

"A writer's ability to describe an essence or truth, or to evoke a sense of wonder fascinates and inspires me, and the imagined through the described is important to my creative process."

How do you enlarge your scope? Don't limit yourself to what you like; discover the point of view of other creatives. Be open to inspiration everywhere you go.

"Walking down the street and seeing posters affects me," said designer and art director of *Print* magazine, Steven Brower, in an interview with Robin Landa. "Just the environment of New York City is so edgy that it adds to creativity."

A creative thinker notices everything and sees all as interconnected. Basketball/ice-cream cones/ Tango/cable TV/the World Wide Web/quilts/voices/trees. Everything has a possible connection, a possible marriage of parts or ideas. Nothing is compartmentalized.

In the art of drawing, some people draw each object. They draw one thing and then move on to another. Inspired and creative individuals draw the space between the objects—the connections!

There are possibilities of relationships, connections, comparisons in everything you see. This book puts a bunch in one place.

It sets you on various courses of exploration, makes you say "ahhh," which then hopefully leads you to say, "Aha!" Great!!

after the search, leave room for accidents

Serendipity. Happy accidents. Along with your proactive search for inspiring visual stuff to add to your imagination's holding pen, keep your mind open to all the happy accidents that occur while working. Some inspiring material may appear without a search. Perhaps one of the most significant accidents occurred when spores of mold invaded one of Alexander Fleming's petri dishes and lead him to the discovery of penicillin. Inspiration can suddenly drop into your lap (or dish). A coffee cup stain, a broken pencil, a corrupt Zip disk, may lead to an exquisite creative work. A distortion from a fax machine may yield a rugged and compelling graphic.

Turn a problem into a solution.

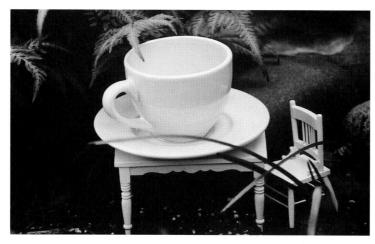

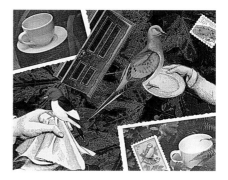

terry garrett, artist
top, left: "magic in the garden" inspiration; *top, right:* "magic in the garden"

"The big questions I work with are: what if? and why not? After I do 'what if'—for instance, 'What would it be like to have a cup in the garden?, I gather my images. Then the question becomes 'why not?' Why not include birds in the cup scenario? I'm free to compose. It also helps that I'm an insane birder."

. . .and your own personal twist

The renowned designer, Paul Rand, was surely inspired by the paintings of Henri Matisse and Paul Klee. In turn, Paul Klee was inspired by the drawings of children (and many other sources). Picasso borrowed from the art of African cultures. Designer George Tscherny used antique toilet pulls as the topic for a beautiful visual book promoting fine paper. Marcel Duchamp had his "ready mades" from the domestic environment.

All creative individuals absorb from history, keep an open eye, gather from the environment, and recycle, reuse, redefine— to form a fresh and new way of seeing. Creative individuals borrow, adapt, translate and add their own personal twist in order to make the work their own.

Be active. Let inspiration visit you. The universe is waiting.

"keep a 'dream journal': 'dreams are the royal road to the unconscious,' according to sigmund freud, and they are a fertile source for discovering creative ideas. in addition to including material from your daily life, dreams express the logic and emotions of your deeper mental processes, those parts of your mind closely related to your creative essence. dreams, with their emotional power, vivid images, and unusual (sometimes bizarre!) juxtapositions, can serve as a real catalyst for your creative thinking. however, dreams are easily forgotten, evaporating like dew in the morning sun. in order to capture your dream, keep a pad next to your bed and write down as much of the dream may occur to you throughout the day, and jot these additional details down as well. underneath your dream description, try to decipher what you think the dream is about, but let its content stimulate your creative imagination as well."

john chaffee, ph.d., *the thinker's way: 8 steps to a richer life*, p. 93
new york: little, brown and company, 1998

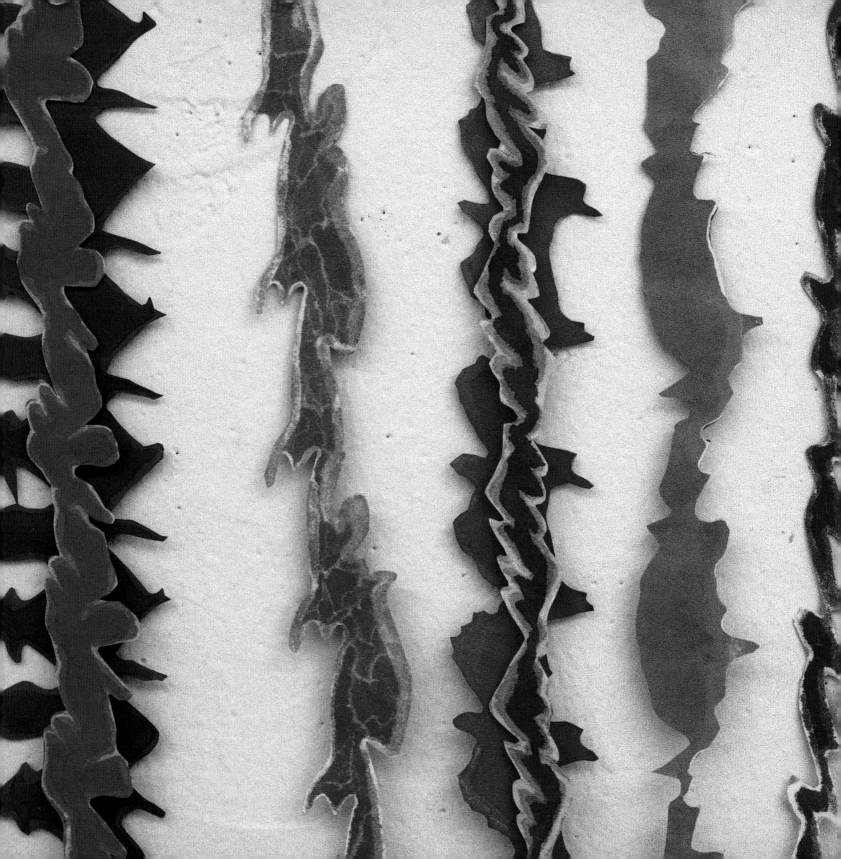

just lines

"no object is mysterious. the mystery is in the eye."

elizabeth bowen

Line is the most subtle of the elements. Sadly, line is often overlooked, dismissed or used in minor ways—as a mere rule or dash.

Yet a line may have great bold character, exquisite lyricism, frenetic energy or quiet tenderness. Line has much more than a dash of emotion. Line may be operatic, coy, furious, demure, crazy.

We love the phrase from art school—"line quality." To be good, a drawing had to have excellent line quality. Did we know what line quality meant? Matisse and Van Gogh drawings were studied for their excellent line quality. Yet, what happened after those first few learning-to-draw sessions? Line was shoved into oblivion so that shape, tone and form could take over. Color was next and it wiped out all interest in line.

True that in a work of design or art, line often plays a minor part. Yet behind the scenes, line almost always starts the creative process. Creative people love to see the "mess of lines" and scratches and marks that were the start of great works—whether their own or the mesh of others.

Line might be ignored by some. However, line has so much potential many creative individuals have not lost interest or pleasure in its use. Personally, we love line and never lost sight of the power of superior line quality. In this chapter we are honoring line as major inspiration in the creative process.

previous image: **mary lum,** "blue lines"; *this page:* **jennifer sterling,** "what do you want your handset to do?"

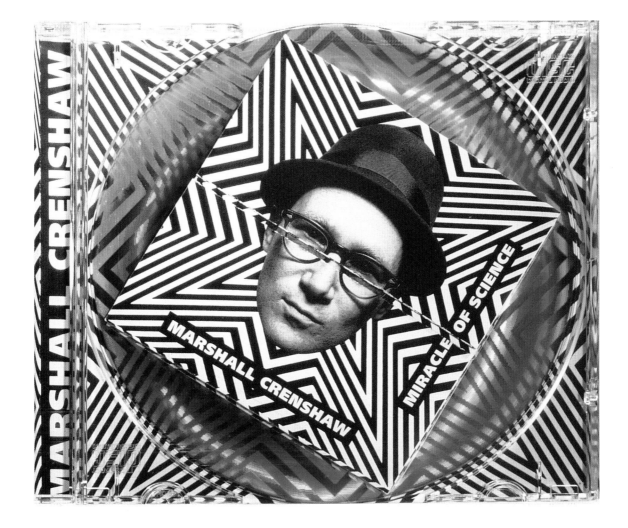

stefan sagmeister, *marshall crenshaw*

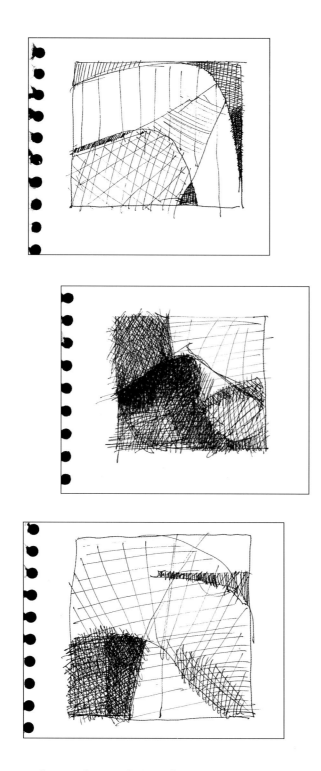

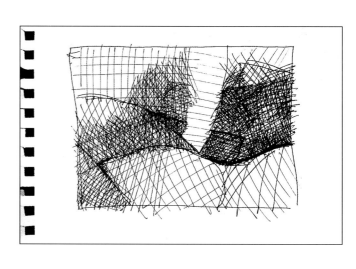

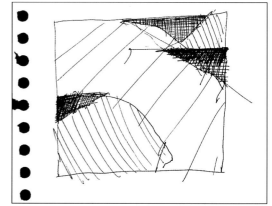

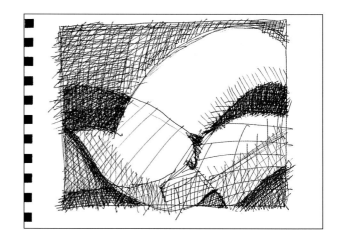

all images on this page: **michael rich,** ink on paper

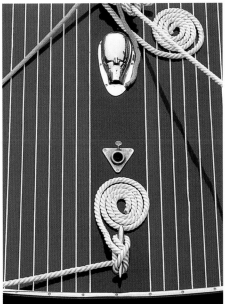

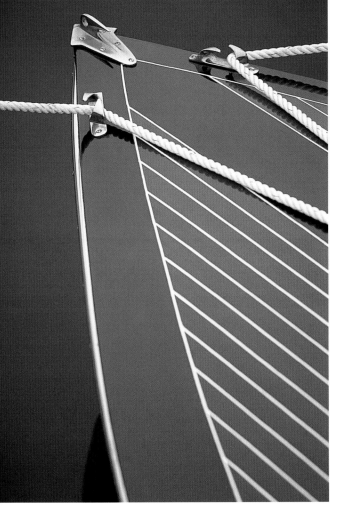

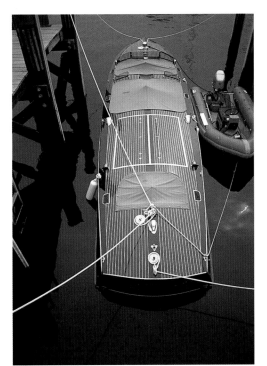

all images on this page: **jordi cabré**

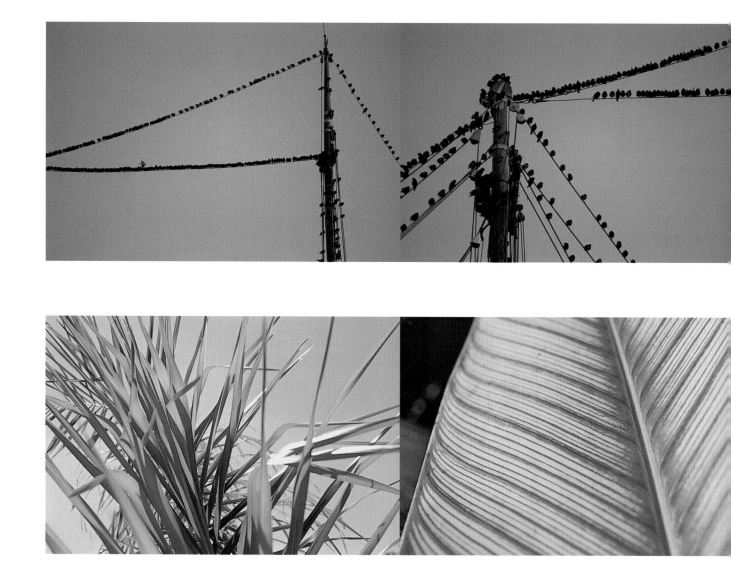

top row: **jordi cabré;** *bottom three images, left to right:* **jilda morera;** *bottom, far right:* **denise m. anderson**

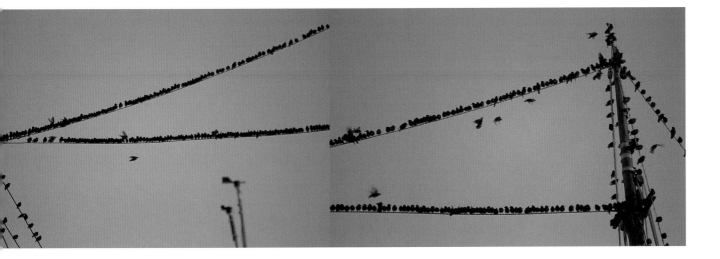

just lines *painterly approach*

"**what is actual, is actual
for only one time.**"
t.s. eliot, poet

three images, left: **robin landa**; *right, top and center:* **larry coffin,** "strands";
right, bottom: **point b,** "twig"

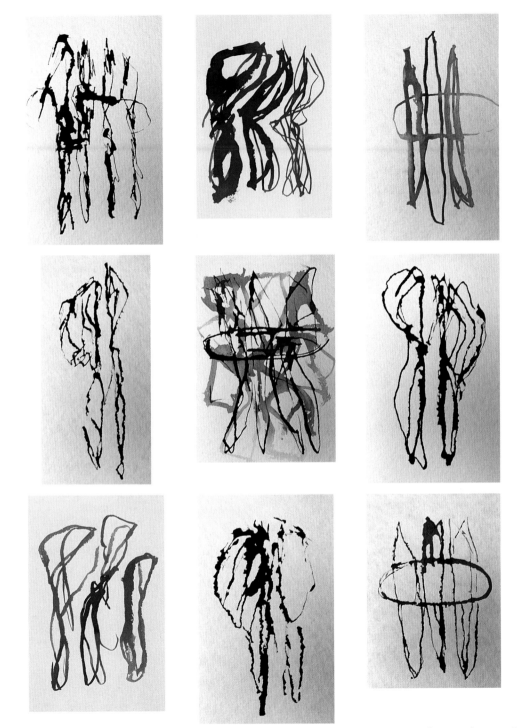

just lines *from a variety of sources*

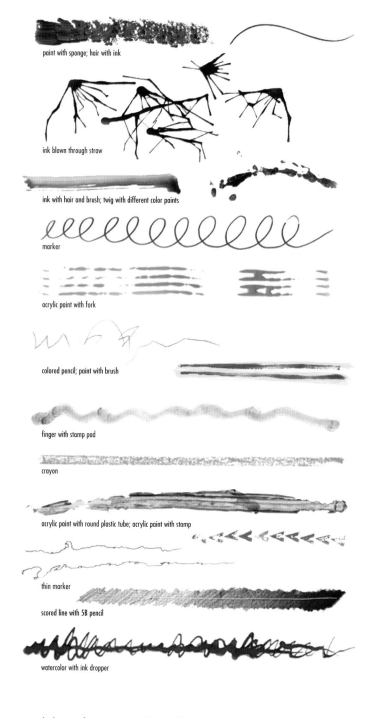

paint with sponge; hair with ink

ink blown through straw

ink with hair and brush; twig with different color paints

marker

acrylic paint with fork

colored pencil; paint with brush

finger with stamp pad

crayon

acrylic paint with round plastic tube; acrylic paint with stamp

thin marker

scored line with 5B pencil

watercolor with ink dropper

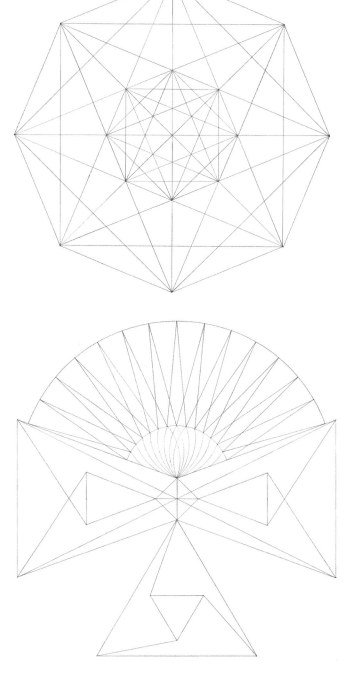

both pages, four center images: **larry coffin;** *line samples on both pages:* **students at kean university**

ink with string; tape

acrylic paint and sugar

acrylic paint with twig; acrylic paint with fork

ball point pen; ink with sponge

soy sauce

5B pencil

paint with fine sand paper; paint with finger

ink with foam brush

acrylic paint with tissue; acrylic paint with nose

colored pencil

ink with brush

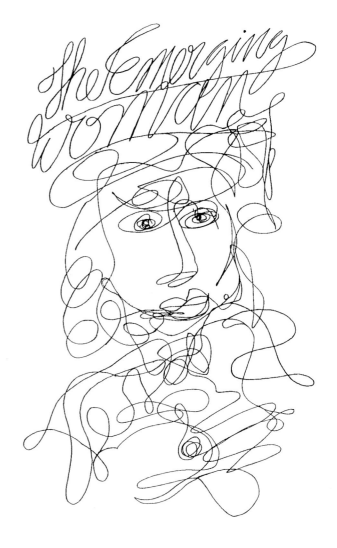

top, left: **mary flock lempa,** sandler brochure logo; *bottom, left:* **david lazarus,** woodcut illustration; *right:* **lanny sommese,** "the emerging woman"

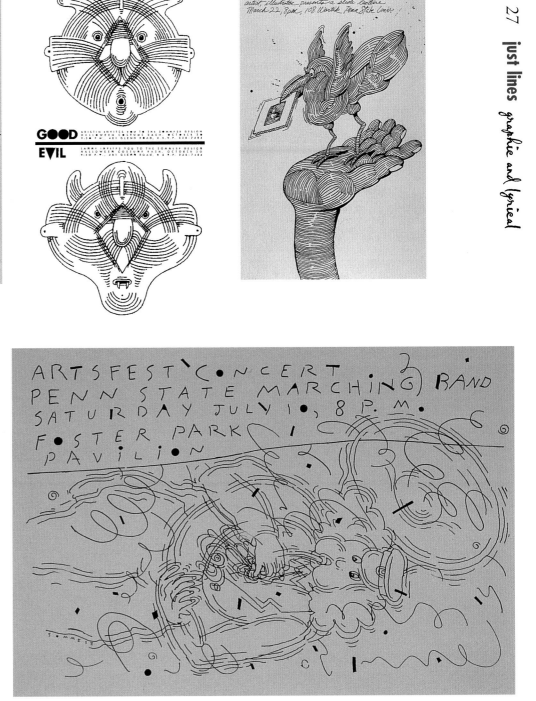

all images on this page: **lanny sommese**

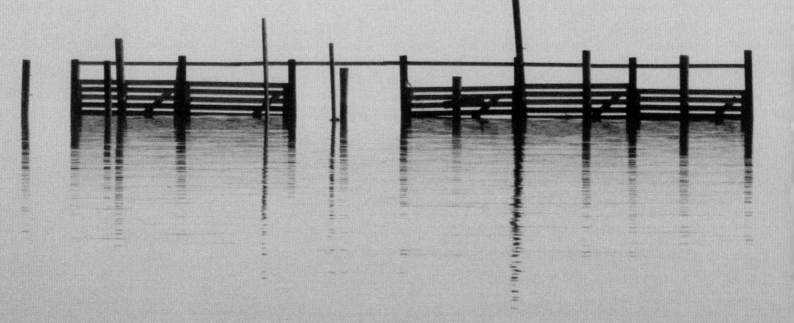

charming shape/excellent form

"an idea is a feat of association."

robert frost

Whether non-objective, abstract or realistic, the creative representation of all shapes and forms derive from our known environment. Look at everything—organic or inorganic. Every shape, everywhere (visible with the human eye or with a microscope or telescope) has the potential of inspiring a creative act or response. Inspiration may be gathered by noting the exquisite curve of a thin crescent moon, the ripples of sand on a beach, a bicycle gear or a microscopic strand of DNA.

We could list a thousand gorgeous, delicate, bizarre, fantastic, unusual shapes to think about. Millions of images are ready to use; an infinite amount more can be invented with the camera, computer or paint, etc. But what good is a list?

A list of inspiring shape and forms may be helpful as a memory refresher (a relief for overburdened brains) or as reference and storage. However, a list or scrapbook of interesting shapes and forms will not inspire until the creative individual sees interactions of shape or form that awakens the mind and heart.

A truly inspired work will be composed of relationships and juxtapositions that provoke thought, create visual poetry and/or touch the emotions or intellect in innumerable ways.

In the following chapter we present a wonderful array of interactions of form and shape. There are provocative juxtapositions that press upon our intellects, formal relationships and atypical points of view that create visual poetry, visual metaphors and a host of images and objects that have inspired designers and artists into expansive realms of creativity.

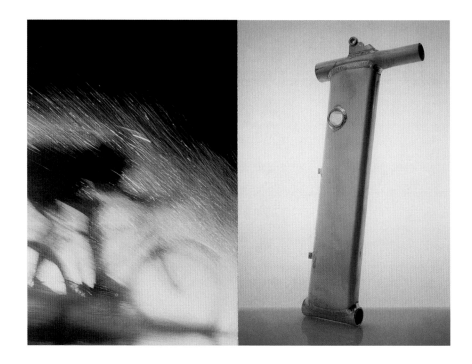

previous image: **kris phillips,** "water & docks"; *this page:* **bob dinetz,** klein bicycle catalog

jennifer sterling, san francisco performing arts poster

IF *Webster's Tenth* DEFINES **tautological** AS "TRUE BY VIRTUE OF ITS LOGICAL FORM ALONE," WHAT IS VISUALLY TAUTOLOGICAL? DOES A RASPBERRY EVOKE THE SAME TRUTH AS A SHOE? VISUAL FORM STRETCHES LOGIC TAUT. HOW DOES IT FEEL TO THINK? HOW DOES IT FEEL TO SEE? HOW DO YOU THINK IT FEELS?

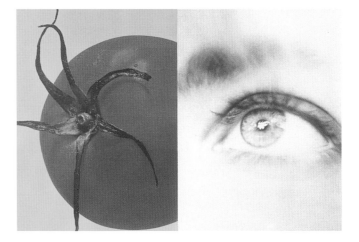

text and images: **jilly simons,** "tautological"

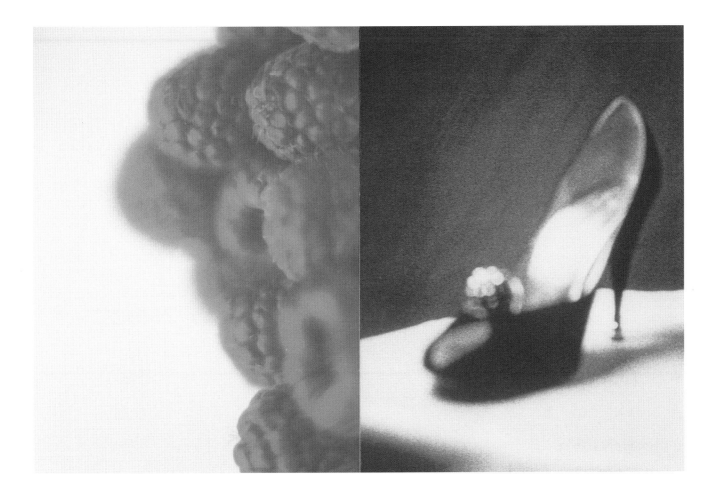

charming shape/excellent form *provocative juxtaposition*

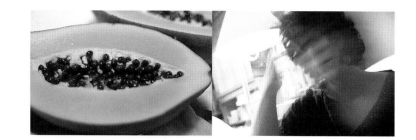

all images on this page: **jilda morera**

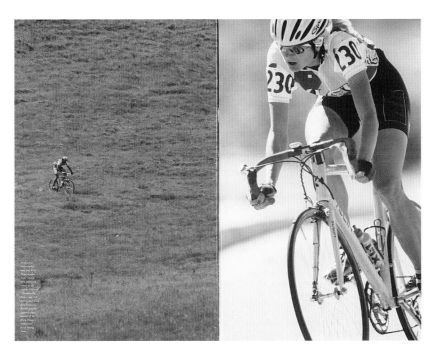

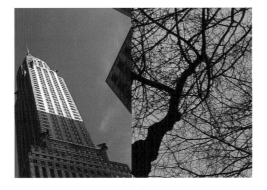

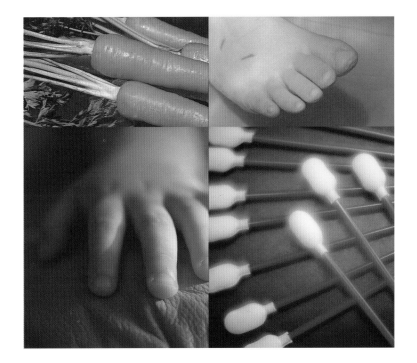

top, left: **bob dinetz,** klein bicycle catalog; *all other images:* **jilda morera**

all images on this page: **mary lum,** "newspaper 1–3"

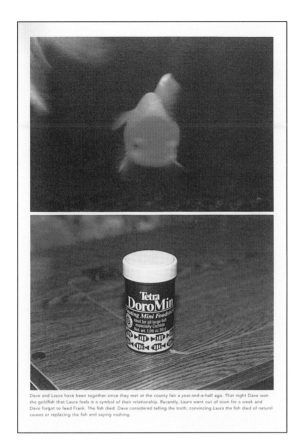

Dave and Laura have been together since they met at the county fair a year-and-a-half ago. That night Dave won the goldfish that Laura feels is a symbol of their relationship. Recently, Laura went out of town for a week and Dave forgot to feed Frank. The fish died. Dave considered telling the truth, convincing Laura the fish died of natural causes or replacing the fish and saying nothing.

all images on this page: **bob dinetz and kevin roberson,** "mohawk options"

charming shape/excellent form *formal juxtapositions*

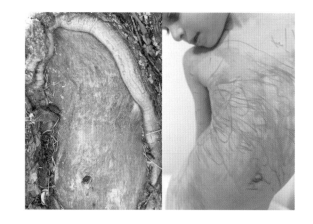

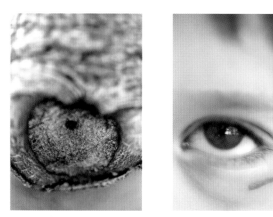

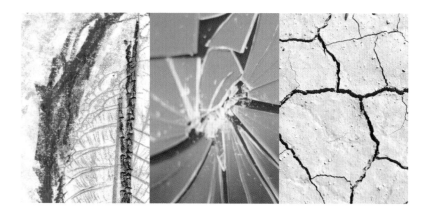

"i look to nature for inspiration outside the design world. there is such beauty, contrast and harmony in nature. it inspires my creative thinking process."
tom ema, designer

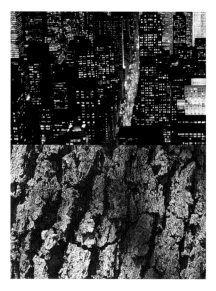

top, left: **lauren rutten,** "belly/knot"; *top, right:* **lauren rutten,** "eye/knot"; *center, left:* **marina leith,** leaf drawing; *center:* **denise m. anderson,** broken glass; *center, right:* **stock;** *bottom:* **jilda morera,** "city lights," "pinoak"

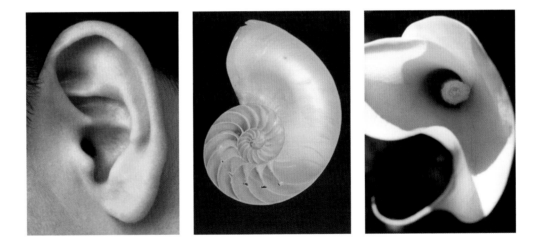

top: **denise m. anderson,** "judy's porch"; *bottom, left:* **denise m. anderson,** "cesar's ear"; *bottom, center:* **lynn toma,** nautilus shell; *bottom, right:* **lauren rutten,** calla lily

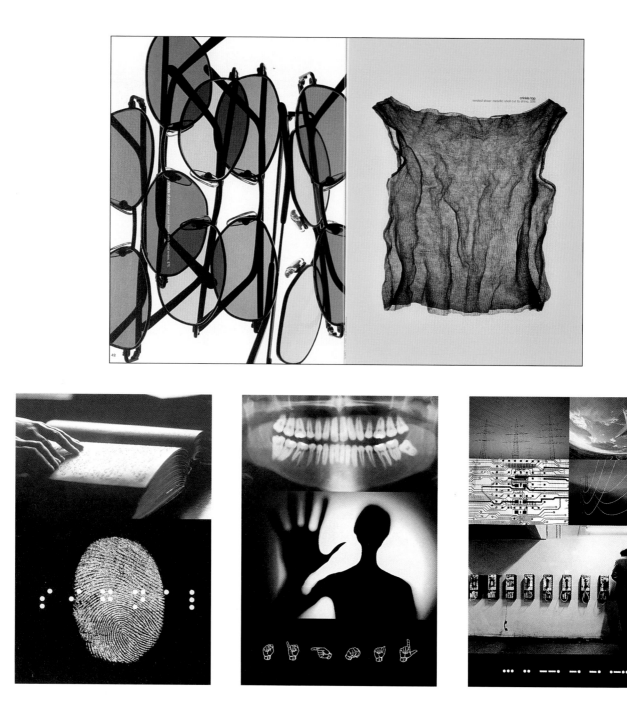

top: **trey lalid,** dkny catalog; *bottom:* **segura inc.,** tony stone images promo cards

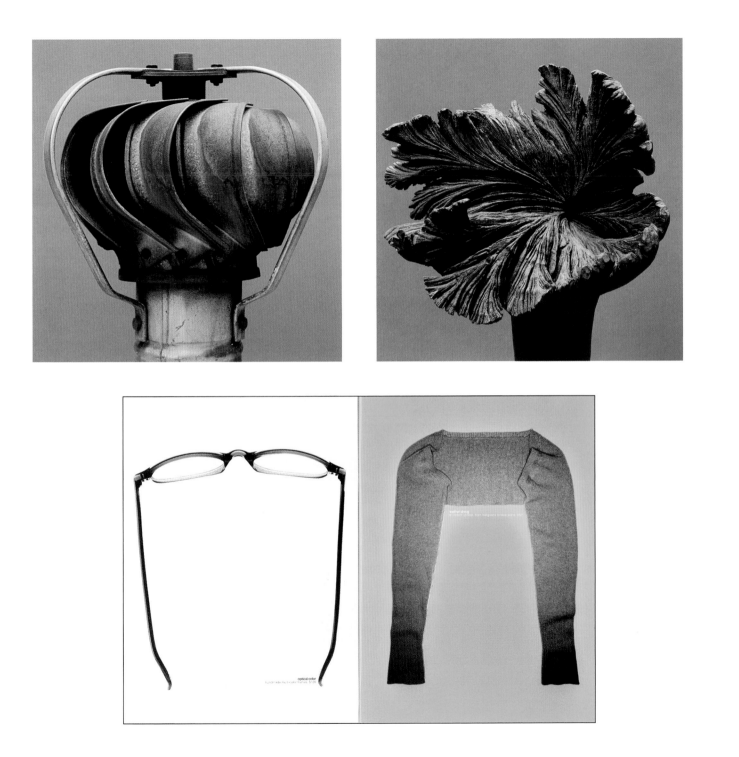

top: **george tscherny,** calendar; *bottom:* **trey lalid,** dkny catalog

charming shape/excellent form *multiple points of view*

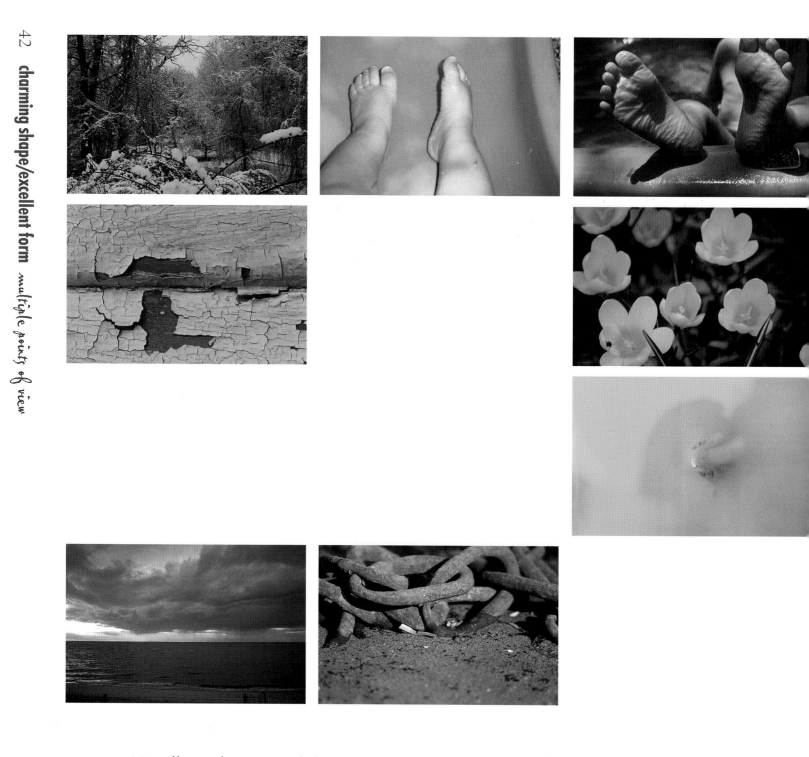

top six images: **jilda morera;** *bottom two images:* **jordi cabré**

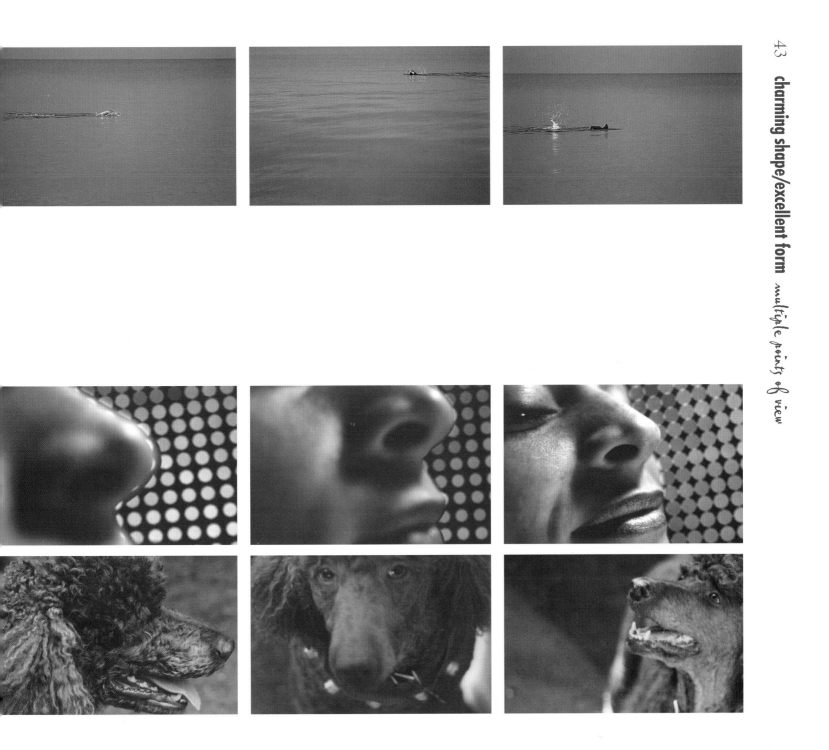

top three images: **jordi cabré,** "swimming 1–3"; *center three images:* **greg leshé,** "nose"; *bottom three images:* **denise m. anderson,** "truffles"

charming shape/excellent form *multiple points of view*

we try to think multi-dimensionally.
through our multi-disciplinary
approach, we see risk management
issues from many perspectives,
revealing multiple ideas and oppor-
tunities, creating **multiple** and
meaningful answers for our clients.

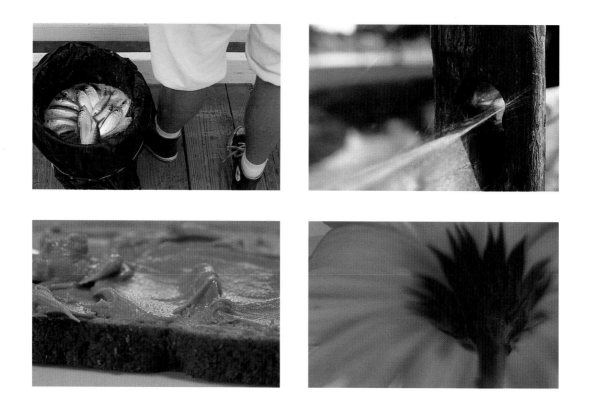

top, left: **kerry leimer,** zurich reinsurance centre annual report*; top, right:* **jennifer morla,** "elements of the table"*;*
bottom four images: **jilda morera**

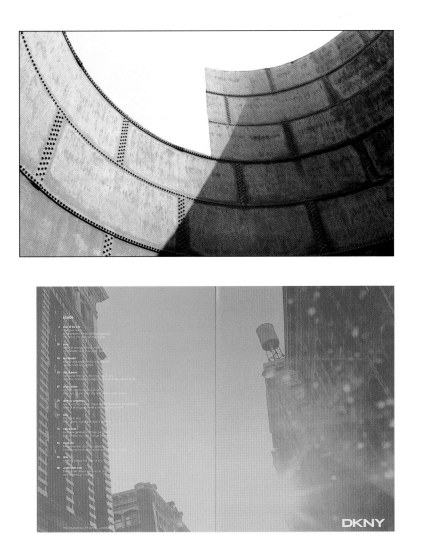

top, left: **anissa m. covello,** "vinnie"; *top, right:* **rob benchley,** "tank"; *center, right:* **trey lalid,** dkny catalog; *bottom three images:* **russell hassell**

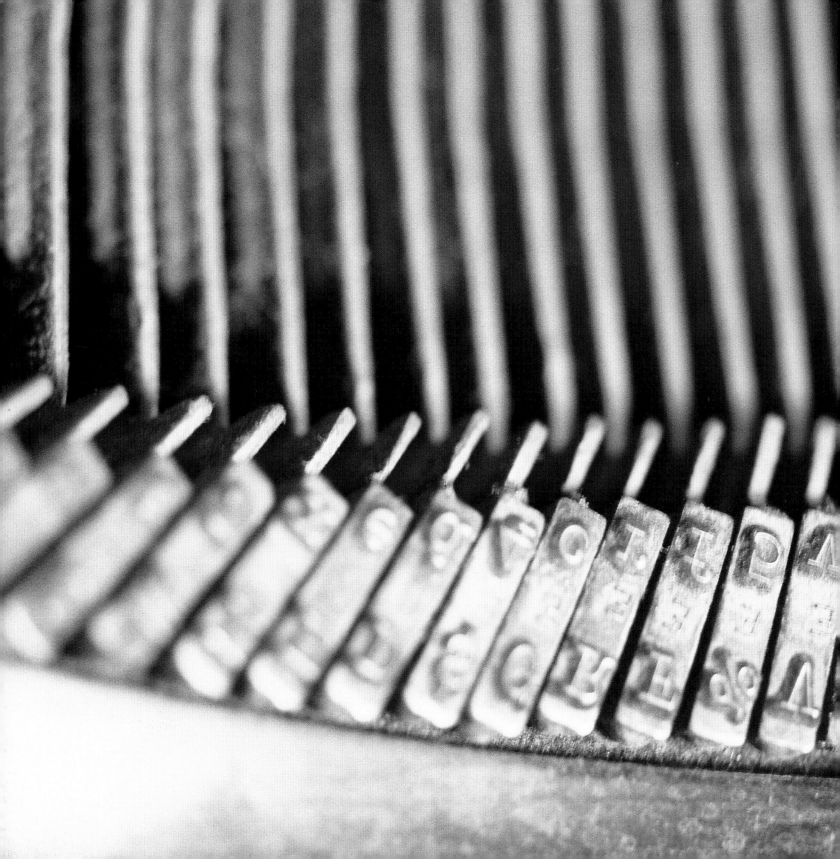

striking type

3

"a letter denotes only one thing—its sound—until its connotative power is extended and intensified by the designer."

philip b. meggs

Letterforms are compelling because of their familiar and perfect formal balance (almost like an egg) and their omnipotent power to communicate. Many creatives gravitate to the medium of design because they have the opportunity to "paint with letters." Some would be content to work with letterforms alone!

Reinterpreting the form of letters without changing their essential character is a favorite endeavor among most designers. How far can the basic form of a letter be transformed before its form becomes unrecognizable? How many ways can be found to recreate letterforms' essential strokes?

Of course, designers, art directors and illustrators need to compose letterforms into words, sentences and paragraphs. Ah, multiples! Even in the recent past, designers had far fewer choices of fonts and basically relied upon a cadre of classics mixed with the occasional new face designs. Now, due to electronic publishing and font designing software, there is a plethora of fonts—many carefully and beautifully designed, others ungraceful, or even unsuccessful. Choosing a font or fonts to express a message has become, at once, both easier and trickier. Mixing or using more than one font in a design has always posed a challenge—yet many designers thrive on that challenge.

At the fin de siècle and now, fine artists were and are becoming fascinated with letterforms and language, including them in their paintings, drawings, collages, sculptures and prints. In the early part of the twentieth century, Stuart Davis, a modernist painter, gingerly employed the curves, swashes and twisted forms of letters in his paintings that captured the pulse of city life. Many contemporary artists also employ letterforms in paintings and handmade books—designing without clients.

Letterforms—their shape, pregnant sound and potential meaning—are inspirations in themselves.

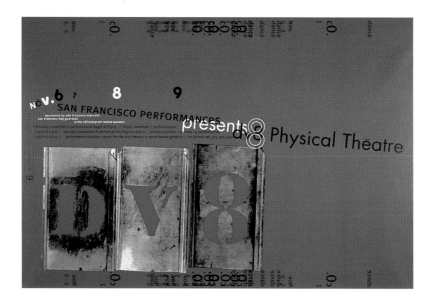

previous image: **yvonne buchanan,** typewriter; *this page:* **jennifer sterling,** "san francisco performances"

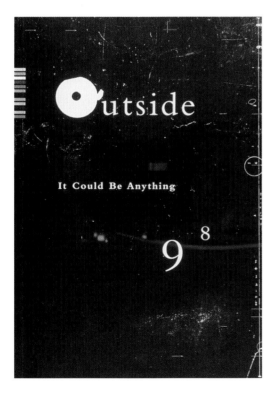

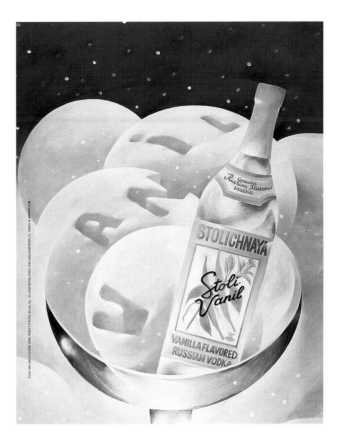

top, left: **courtesy of sony electronics inc.,** vaio logo; *bottom, left:* **jennifer sterling,** "outside…" (book cover); *right:* **margeotes/fertitta + partners,** stolichnaya vanilla vodka ad

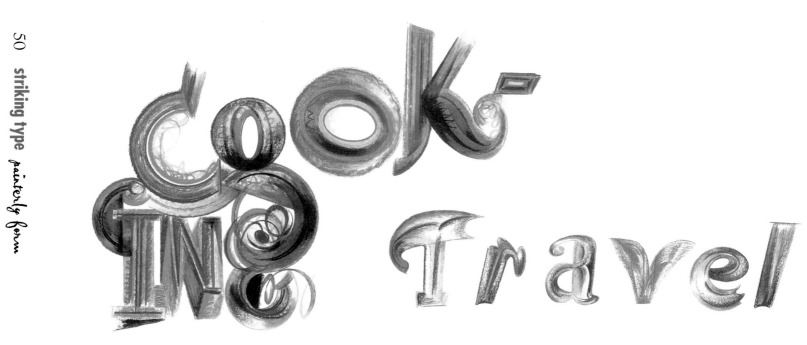

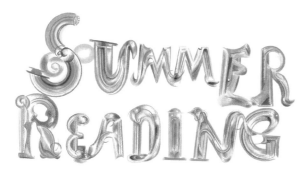

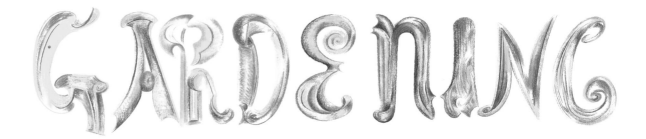

all images on both pages: **ed fella**

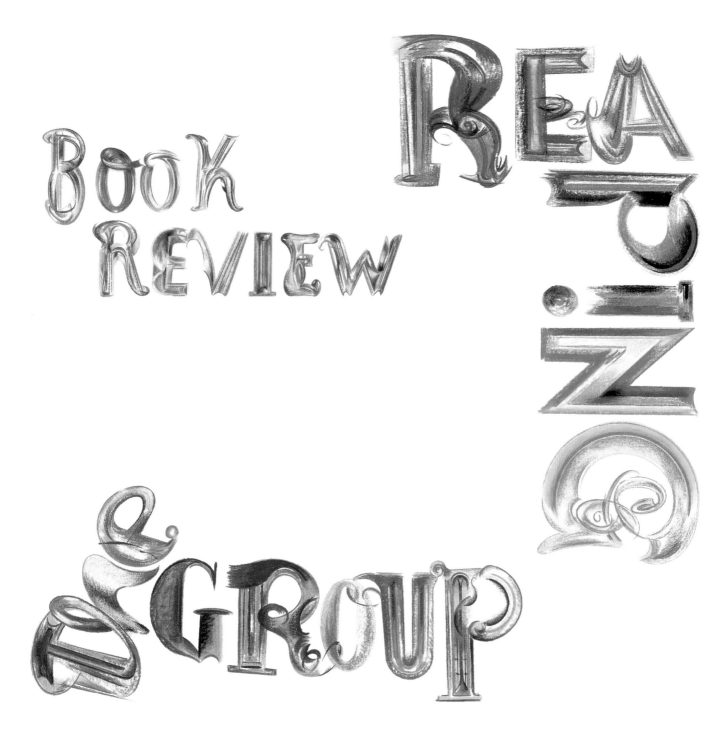

BOOK REVIEW

READING GROUP

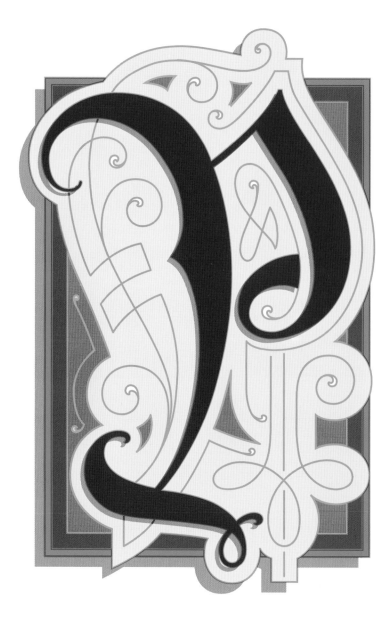

gerard huerta, *initial capital p*

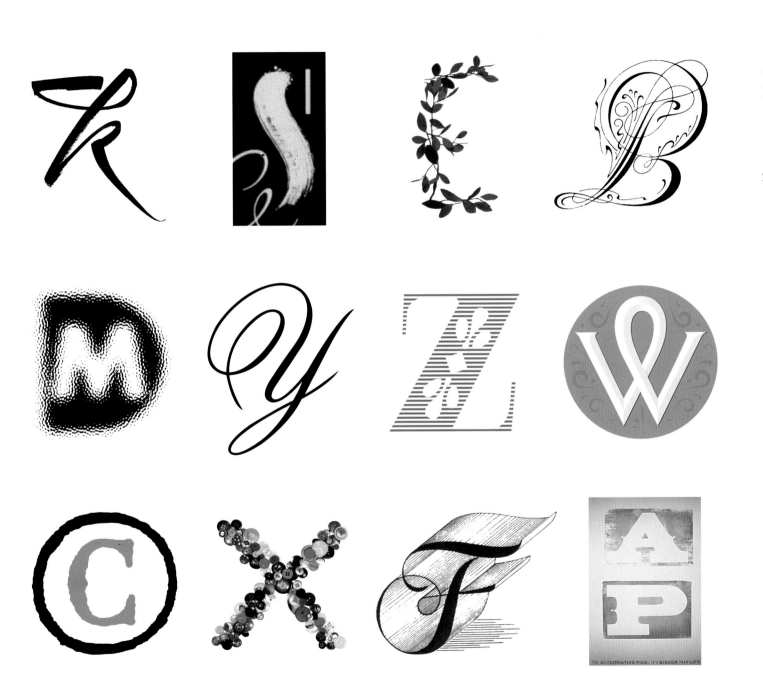

top row: **john stevens,** *k;* **bruce hale,** *s* (from seattle symphony logo); **paula bosco,** "e" leaves; **david brier,** *b; center row:* **lanny sommese,** design mirage logo; **dma,** *y + z;*
david brier, *w* (from the west wind graphics logo); *bottom row:* **karl hirschmann,** o'connell logo; **paula bosco,** "x" buttons; **martin holloway,** *f;* **carlos segura,** "alternative pick" poster

"initial caps are a natural way to give the voice of typography a change of pitch, tone or volume."

martin holloway, educator and graphic designer

martin holloway, initial caps

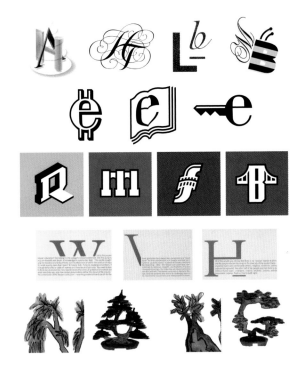

[r]evolution

first row: **jack anderson/david bates,** hornell anderson logo; **john stevens,** ht logo; **anne lieber,** lieber brewster logo; **karl hirschmann,** michael "busy b" bierut;
second row: **karl hirschmann,** ibm "e" business icons; *third row:* **karl hirschmann,** "bridge letters"; *fourth row:* **mark schwartz,** vassar college annual report;
fifth row: **shana leigh acosta,** "bonsai" letters; *sixth row:* **robert louey,** kaufman & broad "[r]evolution" (annual report)

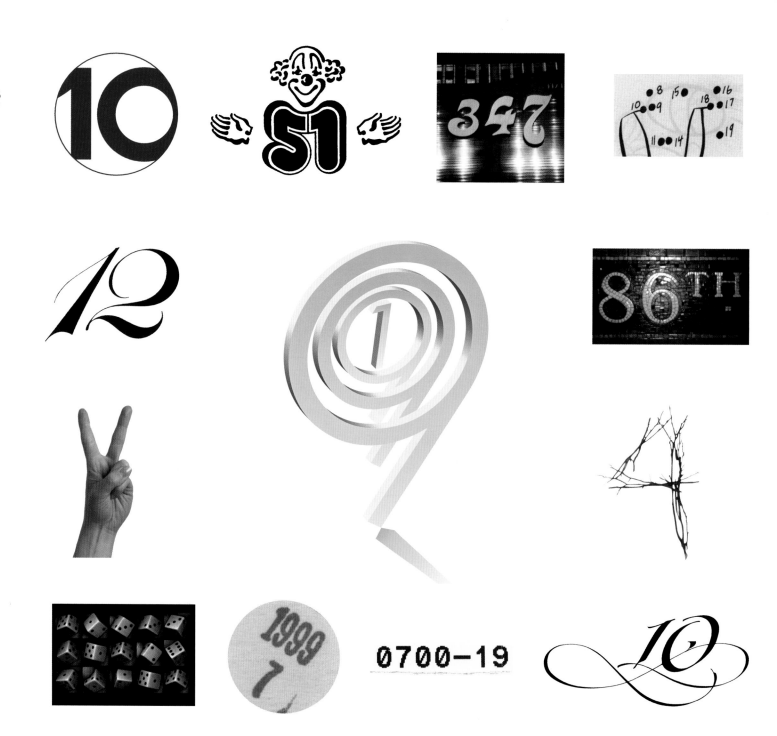

first row: **peter duffin,** 10th anniversary of "midsummer night swing"; **martin holloway,** #51 (from mccully chapters' annual reunion logo); **alejandro medina,** "347" (photo); **dma,** found object;
second row: **david brier,** "12"; **david brier,** 1999 bell press, "a year's worth of views"; **alejandro medina,** subway series; *third row:* **alejandro medina,** "two"; **paula bosco,** "twigs #4";
fourth row: **tom payne,** "sometimes" (interactive cd); **dma,** found object; **dma,** found object; **john stevens,** #10 (from "a decade of literary lions" logo); *opposite page:* **john maeda,** "design by numbers"

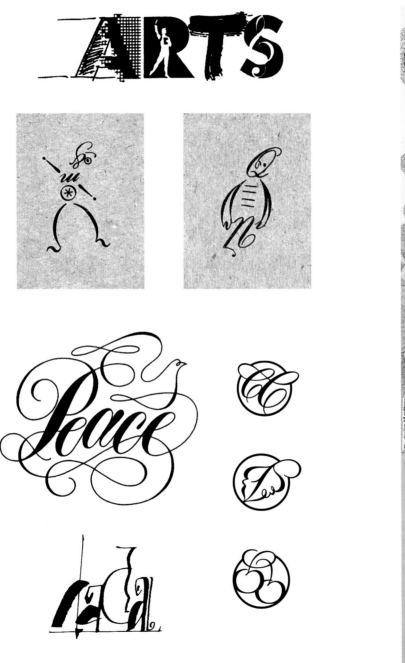

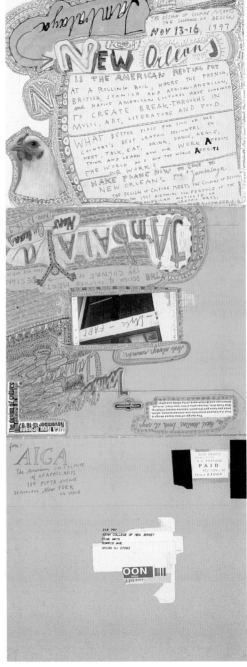

left: first row: **martin holloway,** arts logo; *second row:* **alan butella,** "type characters"; *third row:* **martin holloway,** "peace"; **john stevens,** "cher & leaves";
fourth row: **john stevens,** "dada"; *right:* **stefan sagmeister,** aiga new orleans poster

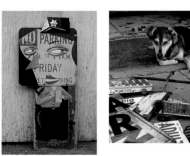

"how to cross a *t*"

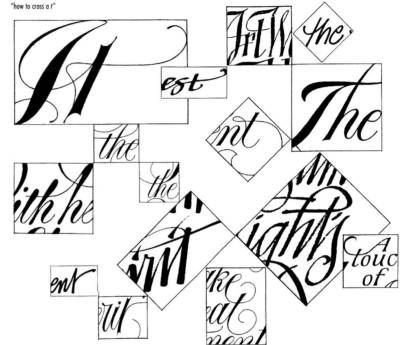

left: top: **mary lum,** "precious moments"; *center three images:* **anthony ciccolella,** cachets for first day covers; *bottom two images:* **donna reynolds,** "meter maid"; inspiration
for "meter maid"; *right: top:* **martin holloway,** "how to cross a *t*"; *bottom:* **alan robbins,** "gutenberg's blocks"; **jack anderson,** tigerlily stationery

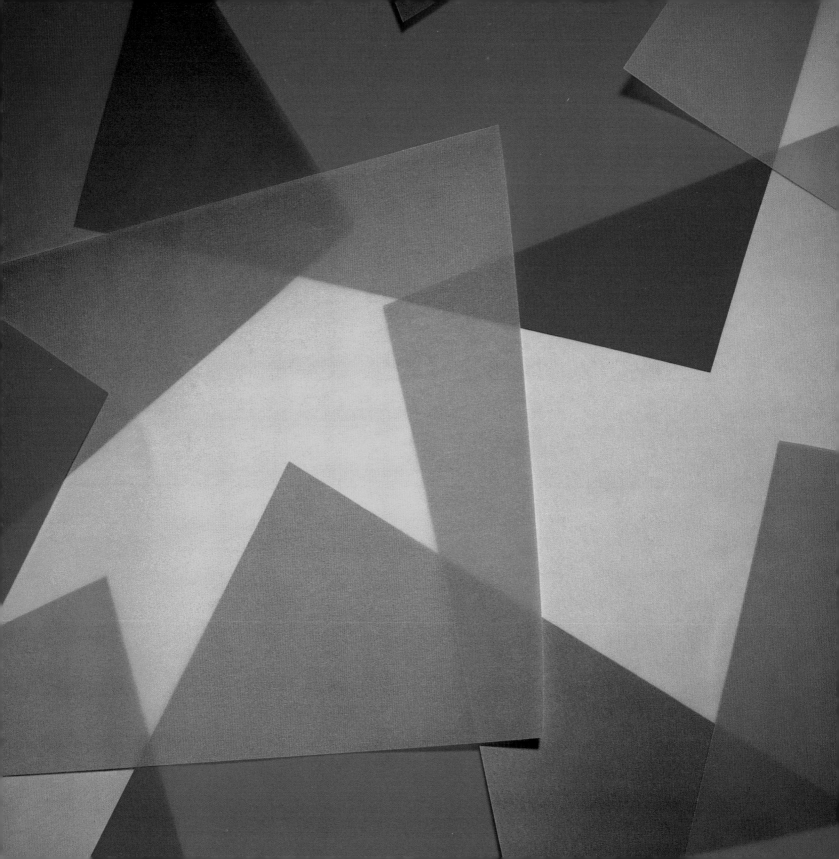

a whole new palette

4

"the meaning of a word—to me—is not as exact as the meaning of a color. colors and shapes make a more definite statement than words."

georgia o'keeffe, artist

In the silent medium of two-dimensional imagery, color itself more than any other element of art and design, has the power to wildly stir emotions. The twentieth-century artist Mark Rothko isolated color from the other elements in order to have color alone lift the viewer into a spiritual experience. Paul Rand, a giant of design, often created color effects for serious play. Whether he used bands of blue to signify a giant of industry or colored flat shapes in a children's book, Rand used color with purpose and sensitivity to meaning. Color may delight, distract, decorate, connote. Color can soothe, agitate or depress. In composition, color is noted first before any other elements register.

Author and scholar Alexander Theroux, in his marvelous two-volume set of essays *The Primary Colors* and *The Secondary Colors,* writes about the six basic hues with "omnidirectional erudition and an omnivorous poetic instinct."—according to the great American writer John Updike.

> Theroux's opening paragraph on blue: "Blue is a mysterious color, hue of illness and nobility, the rarest color in nature. It is the color of ambiguous depth, of the heavens and of the abyss at once; blue is the color of the shadow side, the tint of the marvelous and the inexplicable, of desire, of knowledge, of the blue movie, of blue talk, of raw meat and rare steak, of melancholy and the unexpected (once in a blue moon, out of the blue). It is the color of anode plates, royalty at Rome, smoke, distant hills, postmarks, Georgian silver, thin milk, and hardened steel; of veins seen through skin and notices of dismissal in the American railroad business. Brimstone burns blue, and a blue candle flame is said to indicate the presence of ghosts. The blue—black sky of Vincent van Gogh's 1890 *Crows Flying over a Cornfield* seems to express the painter's doom. But, according to Grace Mirabella, editor of *Mirabella,* a blue cover used on a magazine always guarantees increased sales at the newsstand. "It is America's favorite color," she says.

After you read the wealth of color information found in Theroux's essays and peruse the compilation of color sources, interactions and combinations in this chapter, it's guaranteed that your mind will powerfully ache from the inspirational load.

previous image: **greg leshé,** "cromática paper"; *this page:* **trey lalid,** "dkny catalog"

jennifer sterling, *"pina zangaro fall catalog"*

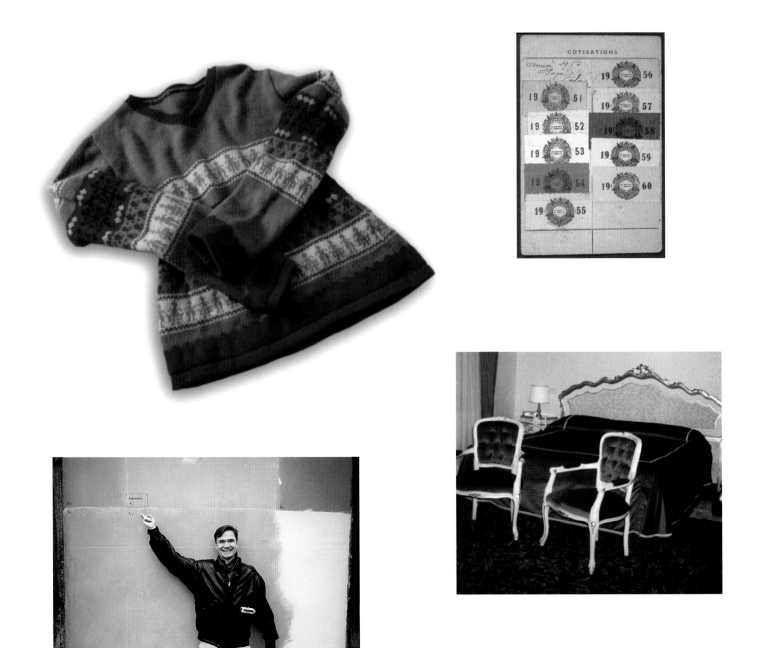

top, left: **greg leshé,** "denise's new sweater"; *top, right:* **mary lum,** "cotisations"; *bottom, left:* **russell hassell,** "this one"; *bottom, right:* **russell hassell,** "blue room in venice"

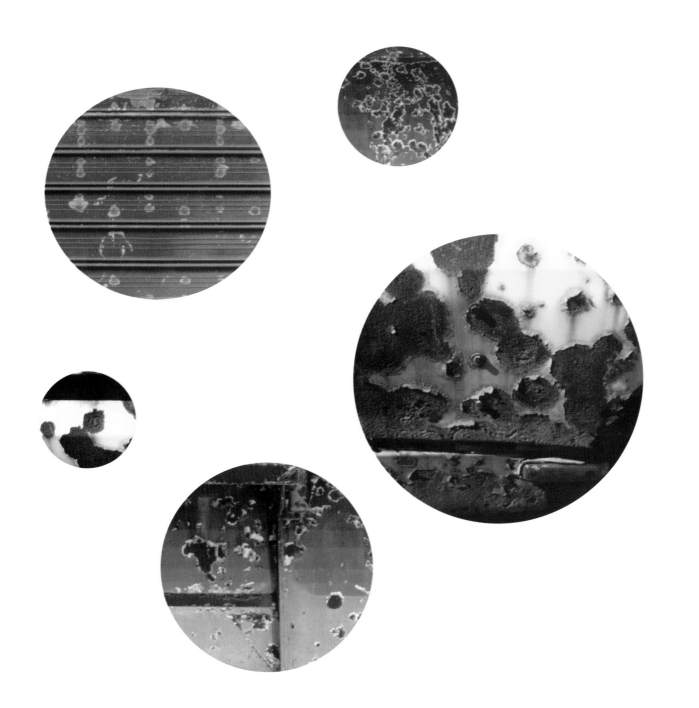

all images on this page: **mary lum,** "blue rust," "red rust" and "yellow rust"

palettes *global history*

gobelin tapestry colors

mozarabic colors

colonial and federal american colors

tibetan colors

all images on both pages: **cesar rubin and rose gonella**

japanese shibui colors

wedgwood colors

"chartreuse, anyone?"

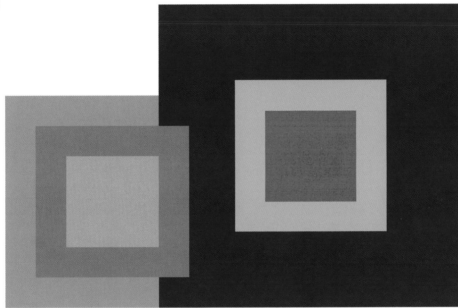

chinese porcelain colors

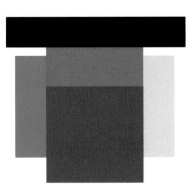

colors from african masks

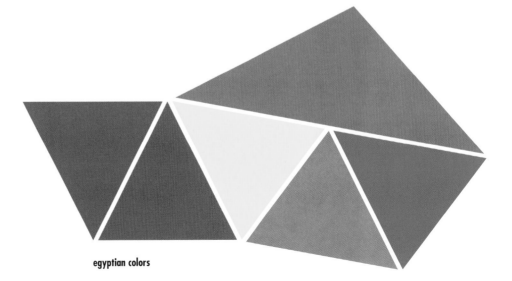

egyptian colors

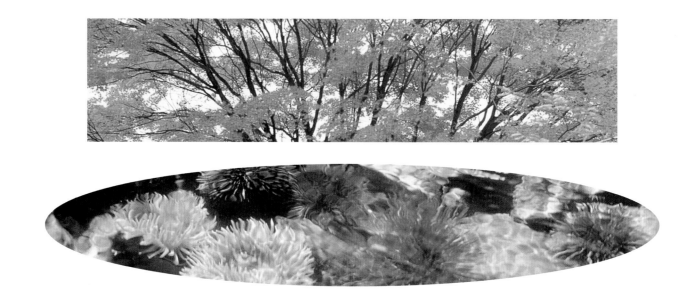

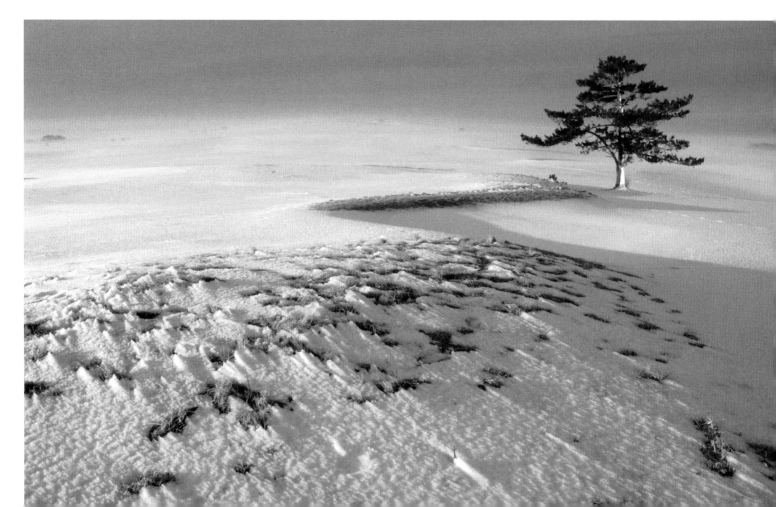

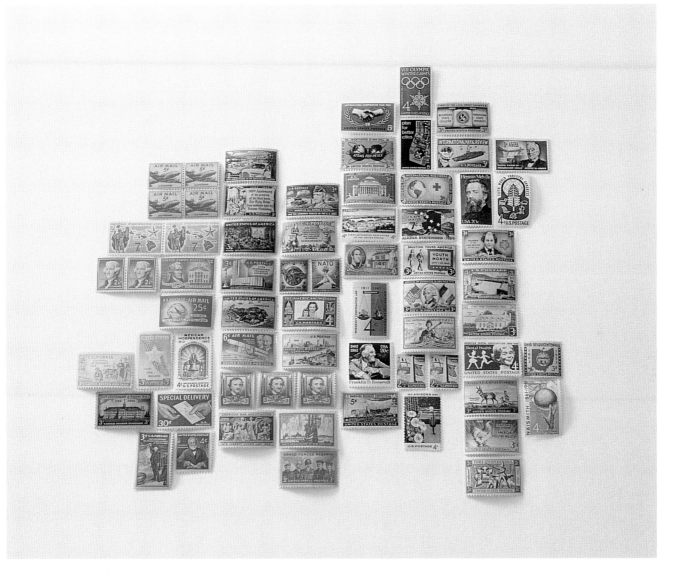

opposite page: **rose gonnella,** "hot autumn palette," "northwest coast"; **rob benchley,** "snow"
this page: **greg leshé,** "rose's stamp collection"

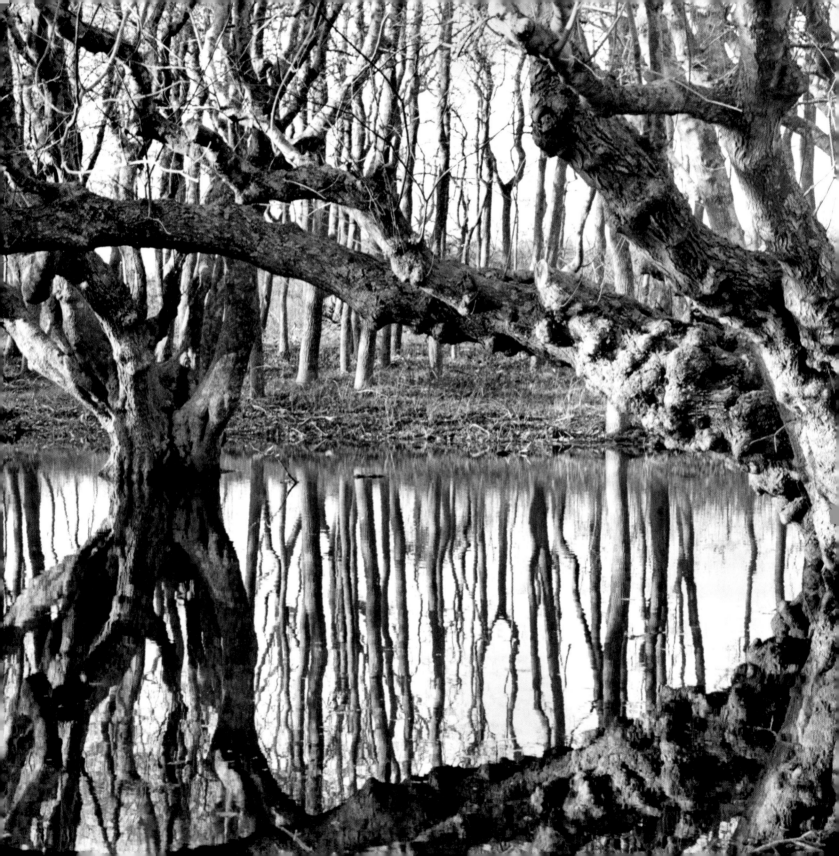

textures and patternspatternspatterns

"i've painted by opening my eyes day and night on the perceptible
world, and also by closing them that i might better see the vision
blossom and submit itself to orderly arrangement."

georges henri rouault

We need touch. We know and enjoy the world through our tactile sense; our sense of touch is perhaps second only to sight.

Textures are naturally compelling—or repelling. When we stimulate our sense of touch, emotions flow. No wonder so many creatives are inspired to use textures—illusionary or real—in design and art.

Textures lead us to patterns. Nature creates random patterns (an oxymoron we love more than jumbo shrimp). Patterns mimic textures. Textures inspire patterns. Patterns inspire touch. Touch inspires emotion.

Emotions communicate. See the pattern?

Good listening leads to understanding.

CARL FERENCE

The pressure is on the CEO, who knows that the workplace is changing but needs help. This is an historic time for workplace design.

GEOFF COLVIN

previous image: **rob benchley,** "swamp"; *this page:* **jilly simons,** "now is our time"

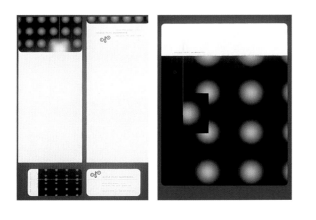

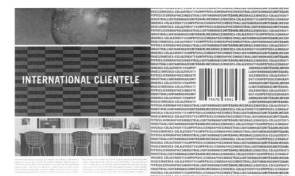

top left: **lisa quirin,** lam research; *middle:* **carlos segura,** "celsius fahrenheit"; *bottom:* **bill cahan,** "san francisco design solutions"; *right:* **cottura,** italian ceramic vase

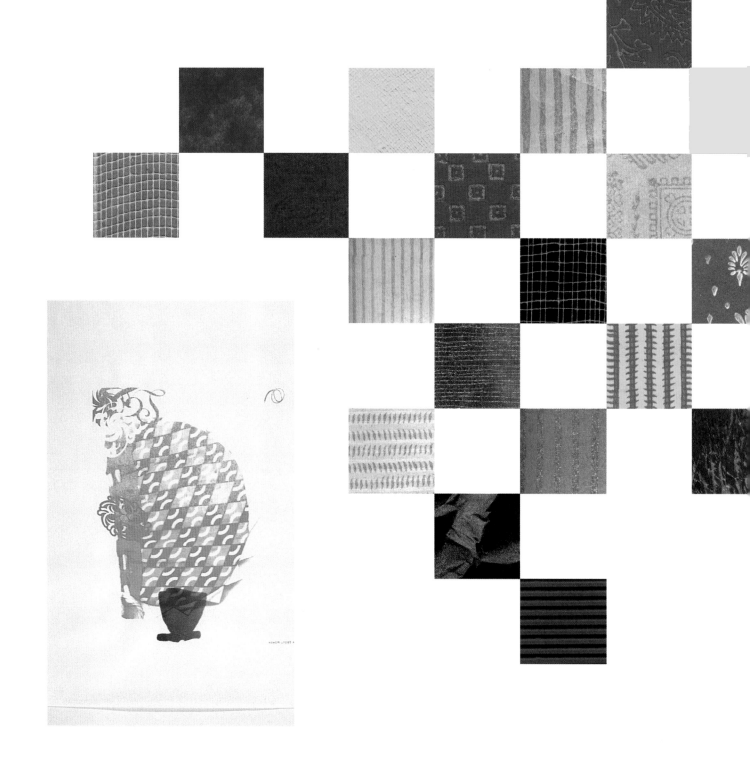

bottom, left: **susan agre-kippenhan,** "how do i look?"; *all other images:* miscellaneous handmade paper samples

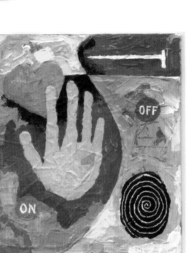

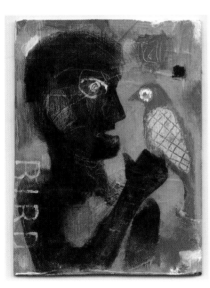

all images on this page: **jim dryden;** *page 76:* **carlos segura,** tony stone promo card; *page 77:* **greg leshé,** "lilly 2000 patch," lilly pulitzer & sugartown worldwide inc.

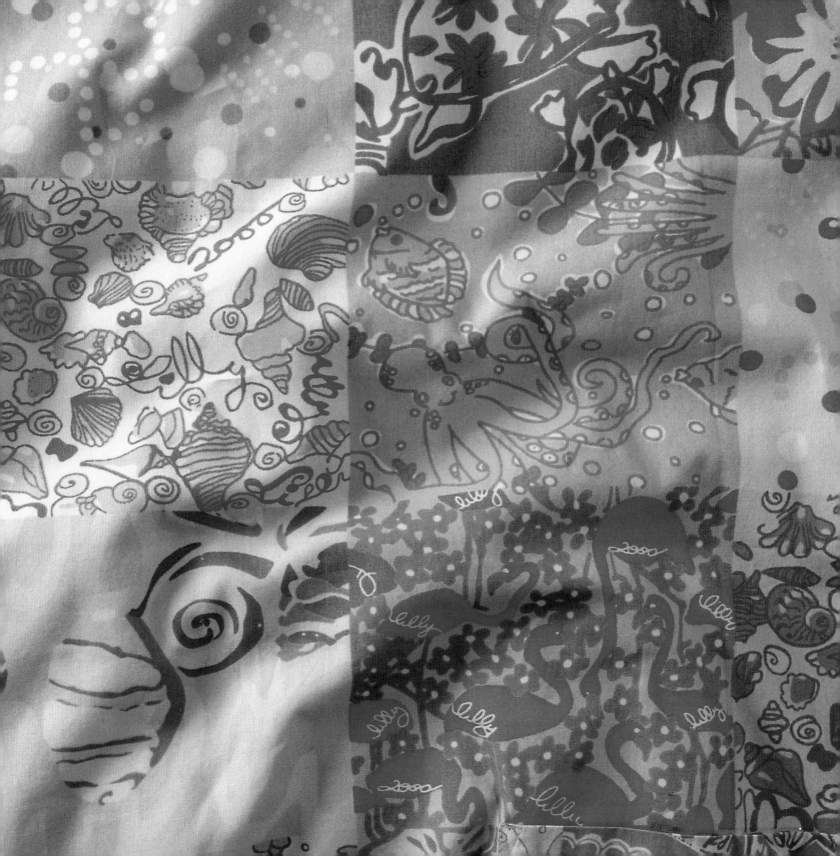

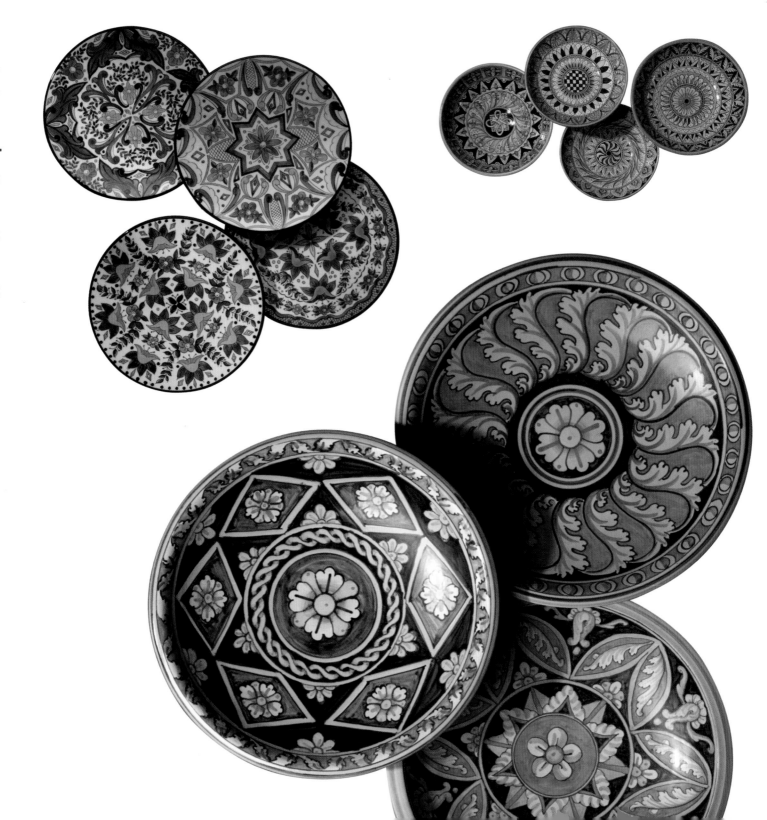

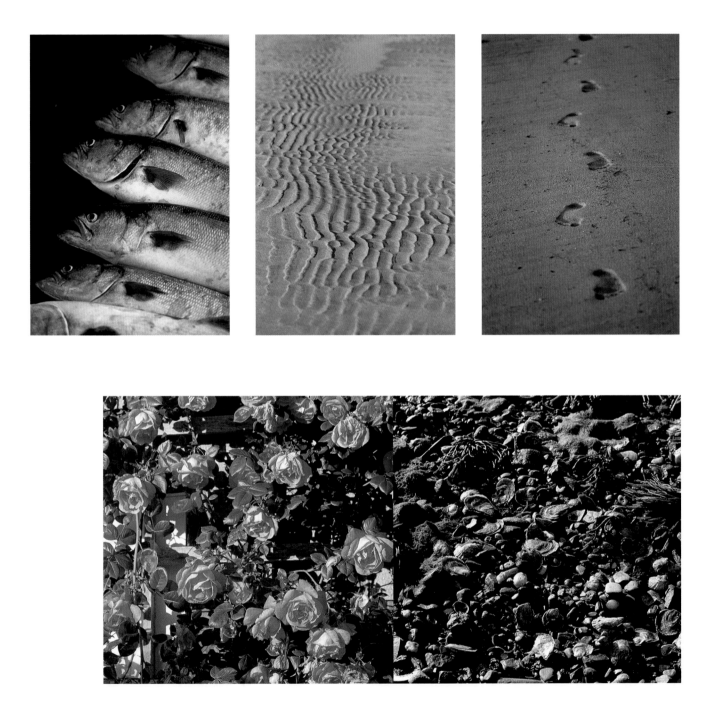

opposite page: **cottura,** italian ceramic plates; *all images on this page:* **jordi cabré**

textures and patternspatternspatterns *paper*

"the humblest as well
as the most exalted
ornaments may one
day become elements
in that revealing
whole, the decorative
style is an epoch."
emile gallé

opposite page: **aiko's art materials,**
various handmade paper samples;
this page: **stock,** 1950s fabrics

found imagery/random objects

Okay, let's talk trash, junk, refuse. From the discards of life, come creative inspiration. For those who prefer to refer to their creative searching and collecting in more polite terms: found objects or random imagery.

Odd stuff, inexpensive antiques, ephemera, memorabilia and plain old junk often are golden treasures that spark aesthetic joy and inspire visual recycling.

Random images with their quirky or charming juxtapositions of common objects are scattered throughout the environment waiting for a serendipitous meeting with a camera. The temporary placement of a twig in snow or a group of boats becomes a moment of visual poetry in need of recording. The record of the moment sits patiently in a notebook ready to be transformed into a image beyond itself.

What is the attraction to tossed-aside, worn, frayed, bent, withered, yellowed, bleached discards? Is it impossible to explain the tantalizing urge to collect odd stuff or the desire to record a temporary image from the environment? The attraction is in possibility. Collect it. Record it. Stash it. Visit it. The randomly discovered objects find new meaning at the fingertips of a creative individual.

previous image: **yvonne buchanan,** wire basket; *this page:* **george tscherny,** "odd & even"

maryanne mastandrea, "louise's trattoria" menu design

found imagery/random objects *personal collections*

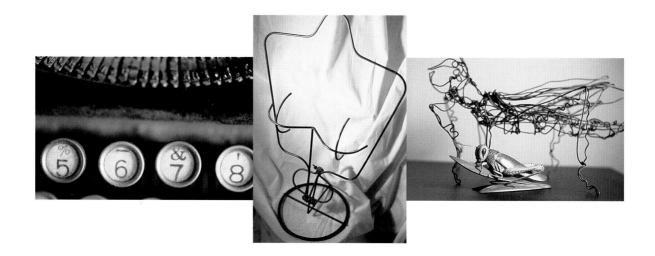

top row: **steven brower,** photos; *bottom, left to right:* **yvonne buchanan,** typewriter, wire dummy, wire grasshopper

three images, top, left to right: **russell hassell,** photos from ancient walls in mexico and a contemporary earth-moving machine;
bottom four images: **donna reynolds,** collected objects and children's drawings

found imagery/random objects *personal collections*

all images on this page: **kris philipps,** collected type

"every great design must contain within
it a balance of memory and possibility."
paul goldberger

two images, top: **susan agre-kippenhan,** vintage scarves; *six images, middle:* **mary lum,** "leaf stains" and "newsprint"
two images, bottom: **jilda morera,** photos

found imagery/random objects *collected and recycled*

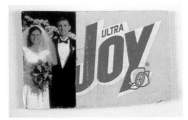

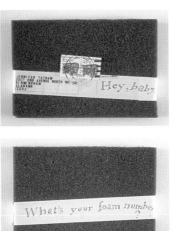

all images on this page: **michael braley/jennifer tatham,** various notes

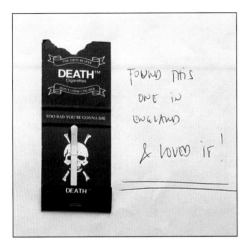

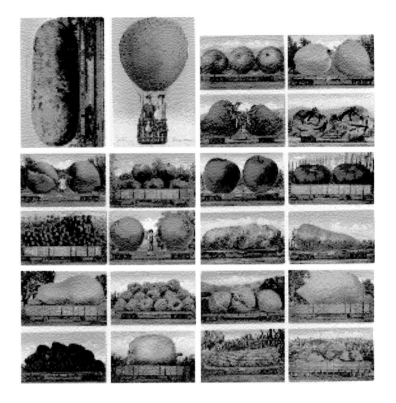

DATE 1936	AIRCRAFT FLOWN				TIME				ELAPSED 187 FWD. 10		FROM	TO .	No. Passengers	REMARKS
	License No.	MAKE	ENGINE	Class	TAKE-OFF HR. MIN.		LANDING HR. MIN.		HRS. MIN.					
6/18	NC619K	TRAVELAIR	J6-5	1A	E.S.T. 3 30 PM		O.S.T. 6 30 PM		2 00		CURTISS FIELD BALTIMORE, MD.	ROOSEVELT FLD.		CROSS COUNTRY, SOLO
6/20	NC619K	"	J6-5	1A	4 00 PM		4 35 PM		35		ROOSEVELT FIELD			SOLO
6/20	NC619K	"	J6-5	1A	5 35 PM		5 55 PM		20		"	"		SOLO - VERTICALS - 360°
6/22	NC619K	"	J6-5	1A	1 45 PM		2 15 PM		30		"	"		SPINS - SPIRAL SOLO
6/22	NC16632	TAYLOR CUB	CONTINENTAL	1	2 20 PM		2 35 PM		15		"	"		SOLO
6/22	NC619K	TRAVELAIR	J6-5	1A	3 55 PM		4 30 PM		35		"	"		EIGHTS - VERTICALS - SOLO
6/23	NC619K	"	J6-5	1A	2 20 PM		3 10 PM		50		"	"		SPINS - EIGHTS - SPIRAL - 360 - 180 VERTICALS - SPOTLANDINGS - Sol
6/23	NC619K	"	J6-5	1A	5 00 PM		5 20 PM		20		"	"		SPINS - SOLO
6/24	NC619K	"	J6-5	1A	3 50 PM		4 35 PM		45		"	"		SPINS - SPIRAL - SOLO
Signature of Pilot	Robert B Hanesker								193 20 Total Time Fw'd		Attested by	John R. Rentoul		

top, left: **stefan sagmeister,** collected objects; *upper right:* **ellen matlach hassell,** collected postcards;

bottom: **jason logan,** pilot log book

found imagery/random objects *individual viewpoints*

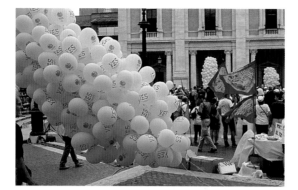

"above all things, get abroad,
see the sunlight, and everything
that is to be seen."

john singer sargent, painter

all images on this page: **michael rich**

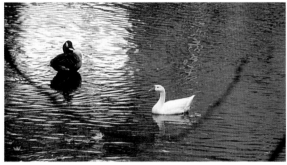

"these photographs record my sense of composition, the relationship of various elements within a rectangular format and the atmosphere created by a certain time of day, of year and of light, shadow and color. many of them, in turn, have served as starting points for my prints and painting."

kris philipps, painter and printmaker

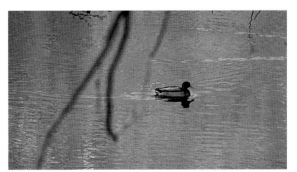

all images on this page: **kris philipps**

"i have been secretly travelling around manhattan taking photographs. it is a secret project because i am looking for hidden images, overlooked visuals, ignored inspirations."

alan robbins, multimedia designer and writer

all images on this page: **alan robbins;** *opposite page:* **denise m. anderson,** *"captiva memories"*

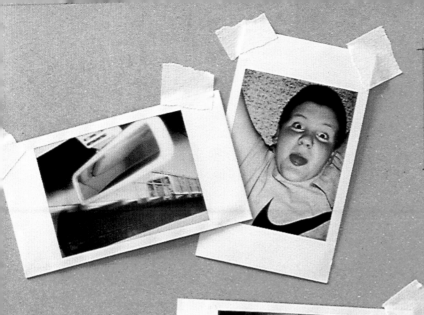

"after seeing a batch of denise's *captiva* photographs, i thought, "wow! i've got to get that camera." fortunately for denise, and unfortunately for the rest of us, her sensibility doesn't come as a *captiva* accessory.

captiva's atypical polaroid format provokes denise into finding wacky angles, cropping images, shooting from unusual points of view and just generally creating distinctive photographs. although denise uses the *captiva* almost exclusively for recording personal events, rather than for her design work, this photographic experience permeates her visual thinking.

some photographers are held hostage by extremely expensive equipment. based on denise's *captiva* oeuvre, anyone can see that it is not the tool but the artist's eye that determines a compelling shot.

polaroid stock is sure to rise after the public sees this case study."

(this testimony to denise was respectfully submitted by robin landa.)

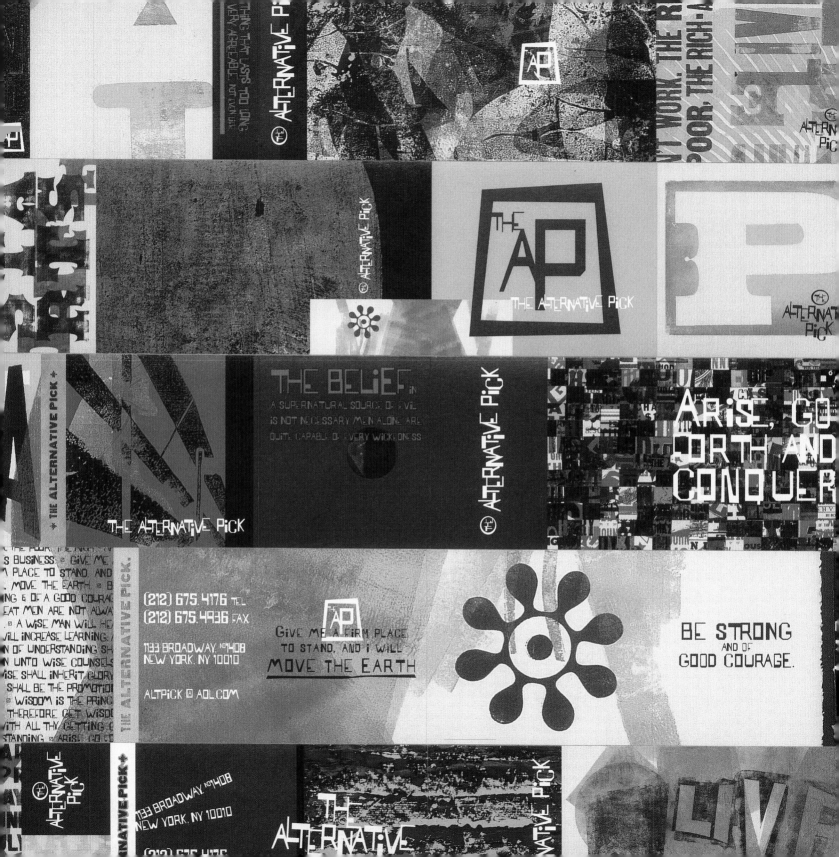

THING THAT LASTS TOO LONG VERY AGREEABLE. NOT MAN...

THE ALTERNATIVE PICK

...T WORK. THE RI...
POOR, THE RICH-A...

THE ALTERNATIVE PICK

THE
AP
THE ALTERNATIVE PICK

THE ALTERNATIVE PICK

THE ALTERNATIVE PICK

THE BELIEF IN
A SUPERNATURAL SOURCE OF EVIL
IS NOT NECESSARY. MEN ALONE ARE
QUITE CAPABLE OF EVERY WICKEDNESS.

THE ALTERNATIVE PICK

ARISE, GO
FORTH AND
CONQUER

THE ALTERNATIVE PICK

THE POOR, THE RICH...
S BUSINESS. GIVE ME...
A PLACE TO STAND. AND...
MOVE THE EARTH. B...
ING & OF A GOOD COURAG...
EAT MEN ARE NOT ALWA...
A WISE MAN WILL HE...
ILL INCREASE LEARNING: ...
N OF UNDERSTANDING SH...
N UNTO WISE COUNSELS...
ISE SHALL INHERIT GLORY...
SHALL BE THE PROMOTION...
WISDOM IS THE PRINCI...
THEREFORE GET WISDO...
ITH ALL THY GETTING ...
STANDING. ARISE, GO FO...

THE ALTERNATIVE PICK.

(212) 675.4176 TEL
(212) 675.4936 FAX

1133 BROADWAY, N⁰ 1408
NEW YORK, NY 10010

ALTPICK @ AOL.COM

THE
AP
GIVE ME A FIRM PLACE
TO STAND, AND I WILL
MOVE THE EARTH

BE STRONG
AND OF
GOOD COURAGE.

ALTERNATIVE PICK

1133 BROADWAY N⁰ 1408
NEW YORK, NY 10010

THE
ALTERNATIVE

mixed up media/techniques

7

"curiosity about life in all of its aspects, i think,
is still the secret of great creative people."

leo burnett

In our age, concept is king. Well, yes, we agree that one must have a concept. But we don't agree that technique must be abandoned or placed at an incidental level at the service of an idea. Technique, ideas, execution and materials must be a single birth from the mind of a designer, artist or illustrator.

At times, it is the materials and technique themselves that can inspire a creative leap. The most ordinary image can be transformed by the way it's created and used. A mark made by a brush loaded with oil paint dragged across a rough surface can be an exciting visual. The feathery lines of etching techniques and the strong graphic shapes made on a scratchboard may in themselves express emotion and provide an answer to a design problem.

Through technique many designers and artists have found unique forms and an original voice. One's voice can be found through years of studying the technique of monotypes or collagraphs, for instance, or by merely stumbling upon a "found" technique—for example, a sun print, or by remembering a playful technique from childhood, such as melting crayons.

Technique can be deliberate or accidental, or a combination of both. Developing skill with pen and ink is a deliberate technical choice. Accidentally distorting an image while copying it or viewing an image that was distorted by a fax machine and deciding to use it, is serendipitous technique. Choosing to create a graphic visual by blowing ink through a straw is both deliberate and accidental.

In this chapter we explore the visual vocabulary of various media, materials and techniques employed by individual creatives. Perhaps the exploration will inspire a new "way" for you.

previous image: **carlos segura,** "alternative pick" (stickers); *this page:* **thibierge & comar,** "fruit d'impression invitation"

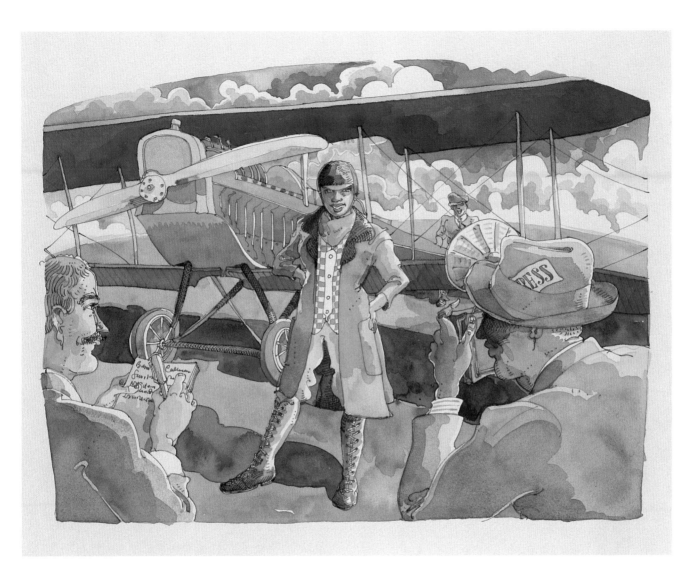

yvonne buchanan, "flyer"

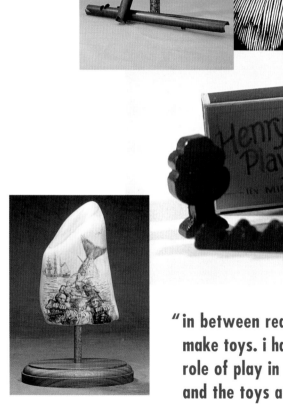

"in between real work projects, i make toys. i have always liked the role of play in the creative process, and the toys are a way to indulge that excitement."

alan robbins, multimedia designer and writer

top, left to right: **elizabeth akamatsu,** "interconnected II" (sculpture); **david lazarus,** "woman seated" (woodcut); **alan robbins,** "hand puppet" (mixed); **layla reino,** "snail" (electronic)

bottom, left to right: **david lazarus,** "scrimshaw tooth" (scrimshaw); **alan robbins,** "henry moore playset" (mixed); **david lazarus,** "end of information highway" (woodcut); **layla reino,** "fan leaf" (electronic)

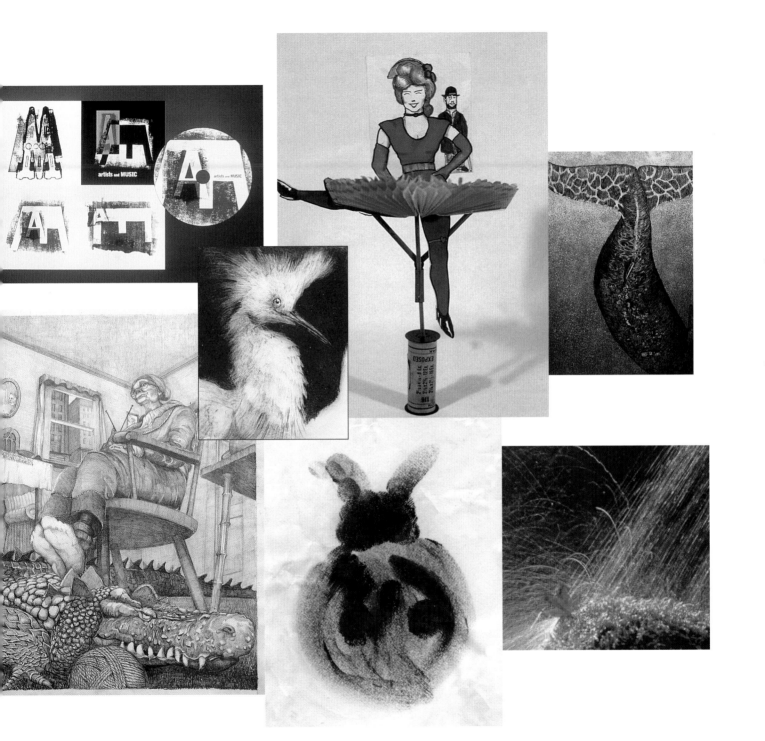

top, left to right: **carlos segura,** "a & m" (rolled ink); **alan robbins,** "woman dancing" (mixed); **david lazarus,** "whale" (etching) *bottom, left to right:* **david lazarus,** "alligator drawing" (pencil);
david lazarus, "drypoint bird" (drypoint); **shana leigh acosta,** "ladybug" (stamp pad and fingers); **layla reino,** "leaf waterfall" (electronic)

george tscherny

judie brophy

dhiraj "migs" mighlani

robert louey

david a. carter

david brier

douglas harp

thomas c. ema

john stevens

denise m. anderson

elizabeth podlach

jennifer sterling

ric tharp

karl hirschmann

stefan sagmeister

jilly simons

thomas payne

yvonne buchanan

all images: **various creative signatures**

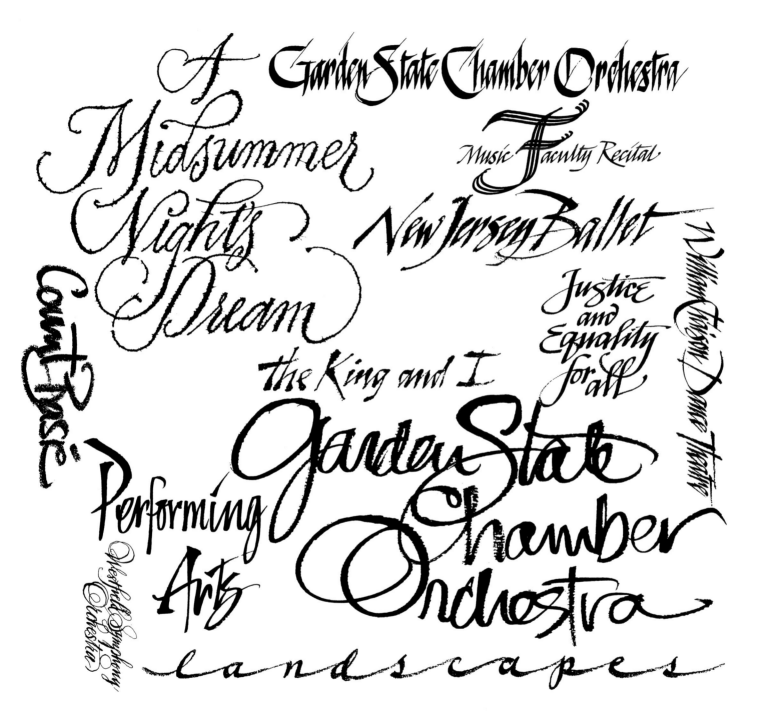

martin holloway, "graphic brush"

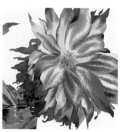

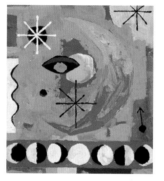

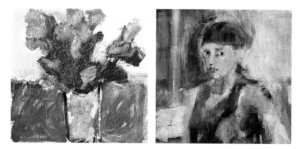

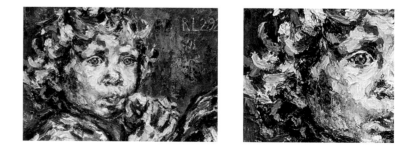

top row: **susan van campen,** "watercolor flower #1 and #2"; *second row:* **jim dryden,** "moon phases"; *third row:* **elizabeth podlach,** "flowers in vase with magenta," "young woman"; *bottom row:* **raye leith,** "marina's apple," "marina's apple" (detail)

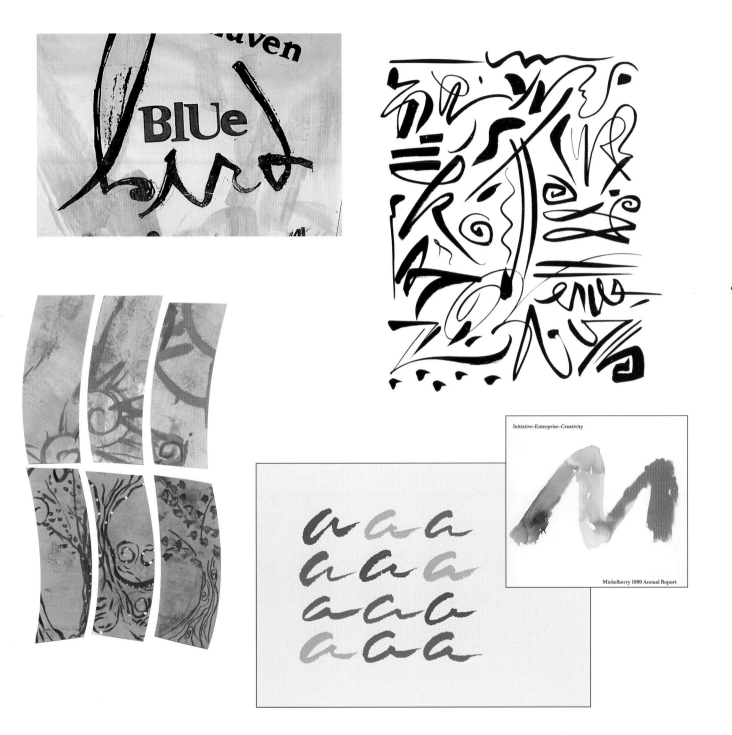

Initiative-Enterprise-Creativity

Mickelberry 1989 Annual Report

top left: **susan agre-kippenhan,** "blue bird"; *top right:* **john stevens,** "brush strokes"; *bottom left:* **julie schroder,** "bookmarks"

bottom center: **thomas c. ema,** "artist's angle logo"; *bottom right:* **george tscherny,** "mickelberry annual report"

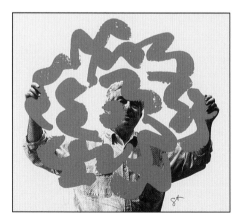

left: **george tscherny,** "graphic design usa"; *top right:* **thomas c. ema,** "voyant folder"; *bottom right:* **george tscherny,** "sva logo"

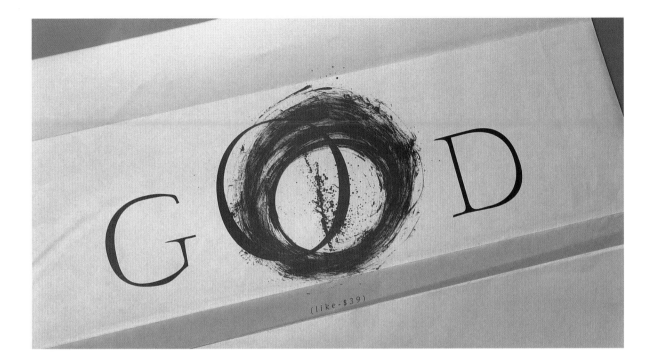

top: **carlos segura,** "godlike type" (poster); *bottom left:* **christina arbini,** "tigerlily"; *bottom right:* **christina arbini,** "logic"

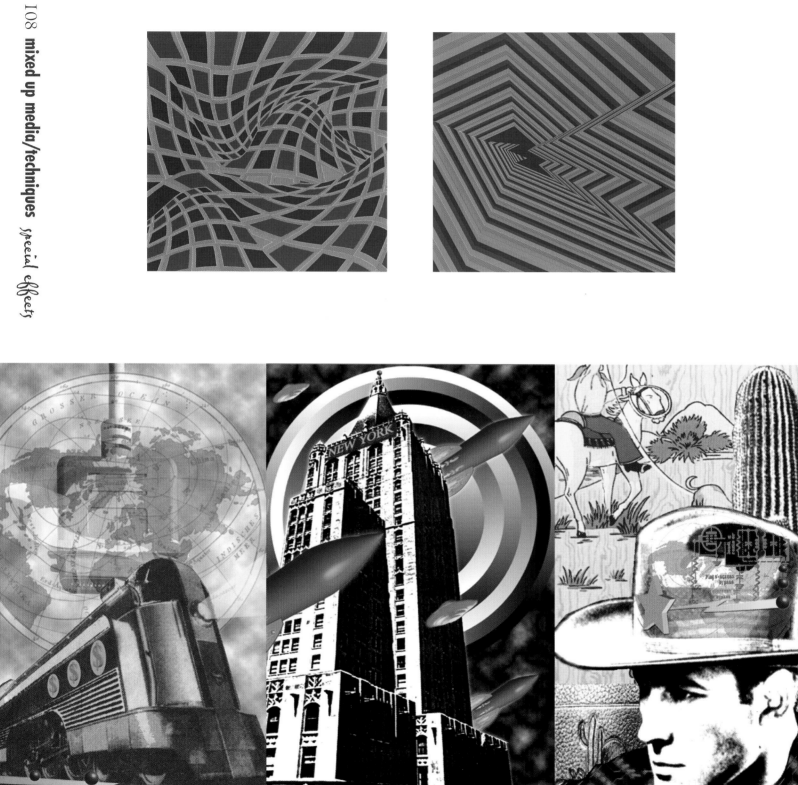

"i have many 'inspirations.' from where i sit at this very moment i can see: a jar full of beach glass, artwork by my daughters (six and ten years), experimental paper-engineering, doodles, wind-up tin toys, russian nesting dolls, books, books and more books, my collection of antique pop-ups and my collection of contemporary pop-ups."
david a. carter, designer, paper engineer and children's book author

About one thing I have no doubt . . .

the Love Bug'll bite you if you don't watch out.

opposite page: top: **laura f. menza,** "bolt warp" and "sea warp"; *bottom:* **chris spollen,** "digital express," "new york" and "electric cowboy"; *this page:* **david a. carter,** "lovebugs"

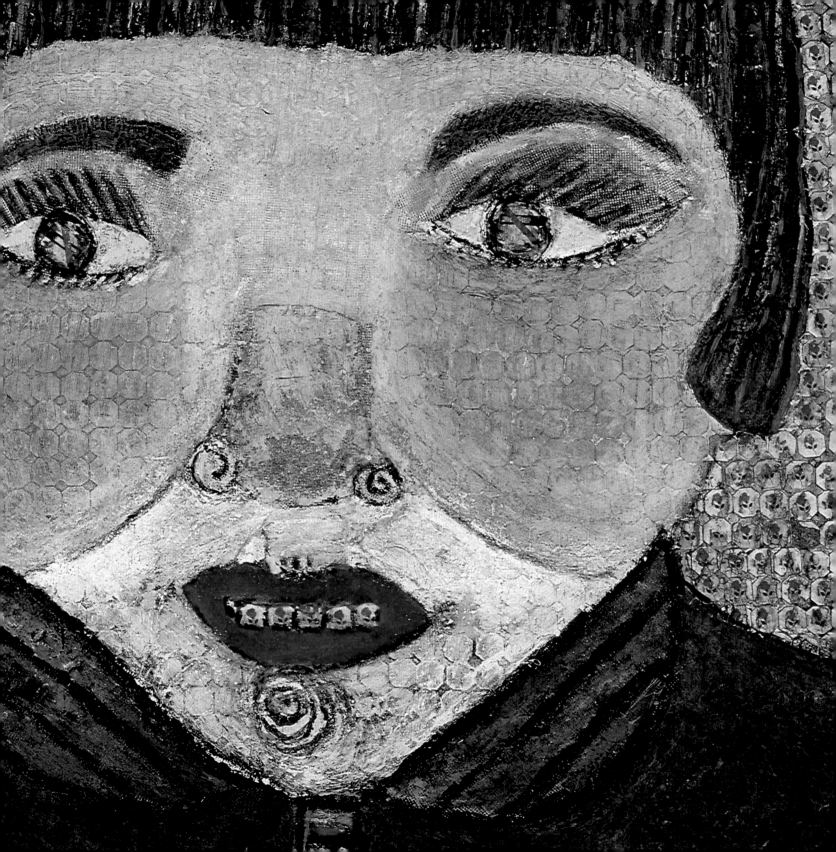

collaged

"to dare every day to be irreverent and bold.
to dare to preserve the randomness of mind which
in children produces strange and wonderful new
thoughts and forms. to continually scramble the familiar,
bring the old into new juxtaposition."

gordon webber

Shards of printed matter, layers of cut paper, crayoned circles, prefabricated images knocking about with painted form, geometrically patterned material, thick paper torn to thin shreds, blocks of cardboard cut into neat angles, a meandering black stroke of charcoal, several tiny found objects—such are a few of the elements and techniques that form the identity of collage.

Aberrant compositions of controlled randomness steadily continue to be employed among creative devotees. It's the audience that perhaps is still tagging along trying to fathom what the erratic juxtapositions and fragments all mean. But don't fear. Collage is a form of visual poetry that appeals to our emotional selves.

Collage is a medium as comfortable with humor, wit and irony as it is with occasional nostalgia, anger or even tragedy.

If you want to know collage, you have to take the time to "read" it. But collage does not reveal itself on the first layer. You have to dig down.

The selected range of creative approaches displayed in this chapter touch (but by no means comprehensively define) emotional and intellectual levels reaching into the familiar, domestic, the whimsical, the surreal and the disturbing. Seeing the collages you will certainly feel the emotion; by thinking about them, perhaps you will be inspired.

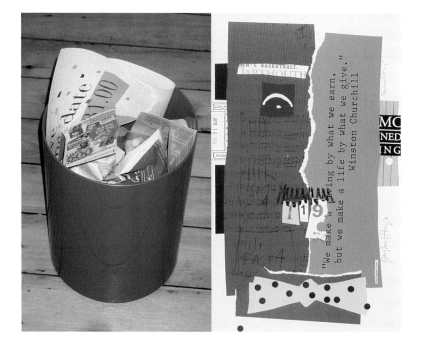

previous image: **anne grgich,** "self portrait"; **douglas g. harp/susan c. harp,** "collage face" inspiration and "collage face"

left: **carlos segura,** "chicago's printers row book fair" poster; *right:* **steven brower,** "stir it up"

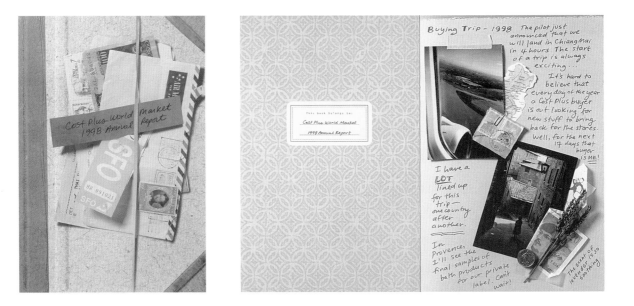

top: **kris philipps,** pages from "life is but a dream"; *bottom:* **maria wenzel,** cost plus market annual report

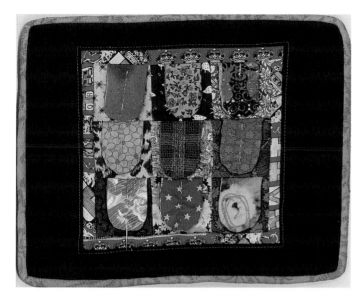

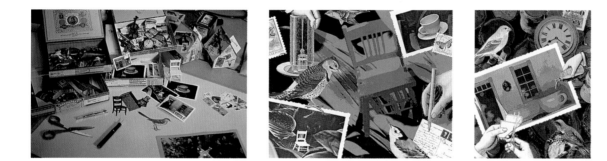

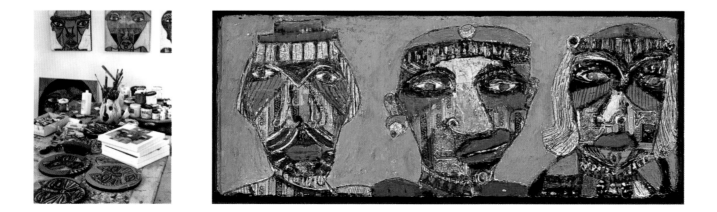

top left: **lynne marie,** "nine needles i knew"; *top right:* **charlotte culot,** "coupe de coinges"; *center:* **terry garrett,** studio table, "garden conversation" and "mona with bluebirds";

bottom: **anne grgich,** studio table and "tahitian retreat 1998"

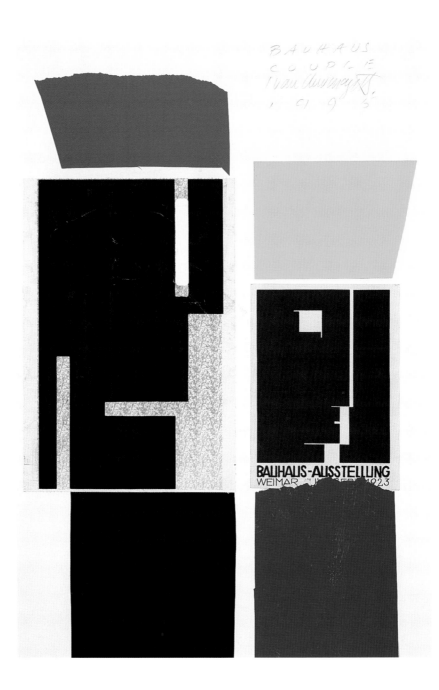

ivan chermayeff, "bauhaus couple"

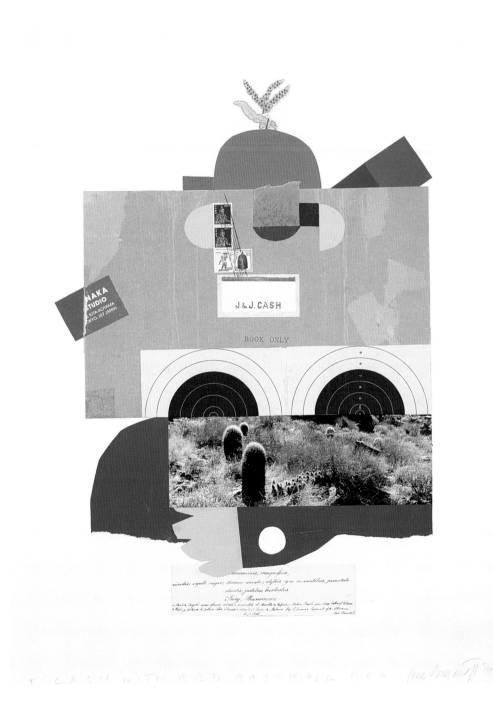

ivan chermayeff, "j. cash with red baseball cap"

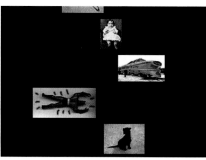
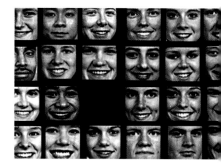
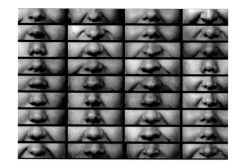
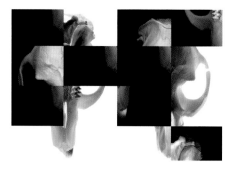

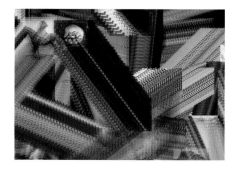

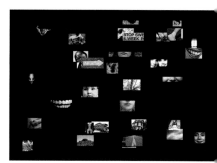

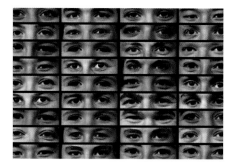
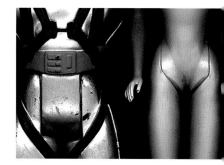

all images on both pages: **tom payne,** "sometimes" (interactive cd)

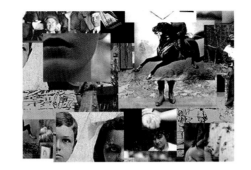

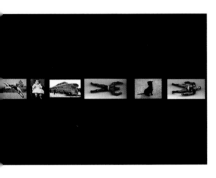
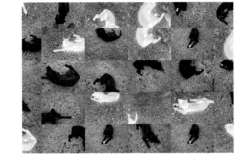
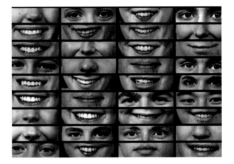

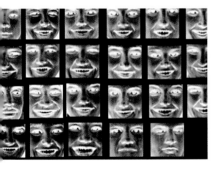

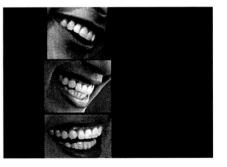

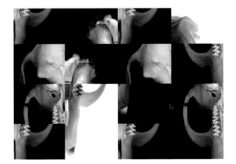
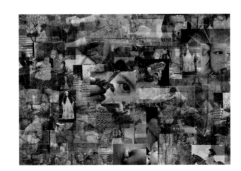

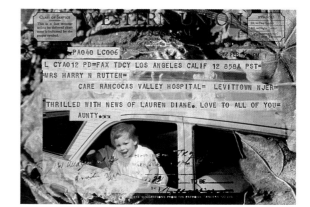

all images on this page: **lauren rutten**

two left images: her mother's "period book" (inspiration for artwork on page); *top right:* "western union"; *center:* "diving in" and "heredity has some influence"; *bottom:* "video mom"

george tscherny, "tulips in pot"

case studies

"genius is the capacity to see ten things where the ordinary
man sees one, and where the man of talent sees two or three."

ezra pound, writer, poet

russell hassell

russell hassell design/new york, ny

Henry's Awful Mistake, by Robert M. Quackenbush, is a children's book about Henry (a duck) who tries in vain to get rid of an ant in his kitchen before his dinner guest Clara (a duck in a sunbonnet) arrives. Hapless Henry destroys dinner, his kitchen, and then his entire house in the process. Henry settles in a new house and again invites Clara (who is presumably very hungry now) for dinner. Just as he goes to the door to let Clara in, he spies another ant. Only this time, he chooses to just look the other way.

Last week, while preparing comps for a client meeting, I held the can of spray-mount the wrong way and cemented the part in my hair for the next few days. Perspective informs many of my design decisions.

A very good friend gave me a small etching on my fortieth birthday. It's an aerial interpretation of gridded farmland with little squares, circles and triangles racing around and bouncing off the land divisions. There are tiny capital letters running along the divisions that read, "EVERYDAY HAS BOTH CHAOS AND STRUCTURE."

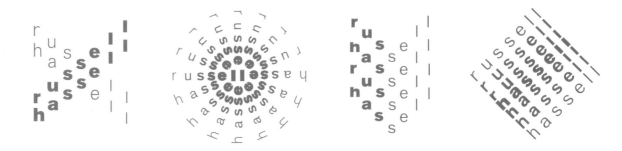

previous image: **russell hassell,** template for "eternal metaphors"; *this page:* "personal logos"

People who don't know I'm a designer ask me if "Russell Hassell" is my stage name. I was born with it. My parents claimed to never have noticed the possibilities. When asked to spell it, I usually reply, "With four *s*'s and four *l*'s." I have been selecting my friends over the years on the basis of the existence of double consonants in their names.

"Dark Decor" was a traveling exhibition of works by artists who use pattern and decorative elements as devices to camouflage the more sinister aspects of their work. The concept was reinforced by the catalog's dust jacket, actual wallpaper in a lurid bronze and black metallic prepasted paper with black flocking. Since the taste police had been through Manhattan, I had to go out to Brooklyn to find something this wonderfully awful. The paper had just been discontinued but there was enough left in the supplier's warehouse to fill my needs—an overage from the redecorating efforts of a local cocktail lounge.

After finding the paper, the next hurdle was to figure out how to apply type. My printer, The Studley Press in Dalton,

"dark decor"

"eternal metaphors"

Massachusetts, experimented with different applications. Foil stamping worked the best. The shiny bronze metallic foil stamped onto the paper had the added visual interest of changing texture as it went over the flocking. The printer cut individual sheets off the rolls, stamped the type and folded them as dust jackets.

Only 750 books were produced since the exhibition had a limited tour. The catalog sold out and the client expressed interest in doing a second printing. Of course, the wallpaper was no longer available.

"Eternal Metaphors" was an exhibition of works by contemporary Italian artists. The concept was to try to visually convey the metaphysical, mythological, religious and contemporary concerns of the participating artists. To echo these themes in the catalog, the inspiration came from the star-mosaic of the cupola in the Mausoleum of Galla Placidia in Ravenna, Italy. It was also subliminally reminiscent of my grandmother's spaghetti colanders.

The navy cover stock is metallic gold foil stamped with type and then die-cut with 300 radiating holes. The endleaves are one-sided gold metallic foil that comes embossed with a swirling, alchemical pattern. From a supplier of specialty papers in Long Island City, this foil paper is generally used to wrap candy boxes.

The endleaves were folded back on themselves to provide structure and metallic surfacing on both sides of the leaf. Visible through the holes, the paper provides a secondary swirl beneath the radiating holes. In keeping with the Byzantine spirit, comps for this job were labor-intensive—I sat on my kitchen floor and stamped those holes one by one with a leather punch. These were the

"critiques of pure abstraction"

"critiques of pure abstraction" *(interior)*

days before my work on the computer, so Ellen, my ex-wife, plotted the geometric points with a compass and I spaced the type in the center circle by hand. The accomplishment means little when you consider that 1,000 years earlier, the same pattern had been plotted on the inside of a dome.

I have the "kiss of death" when it comes to selecting cover stock. If the paper is a little odd, I'm bound to like it, and the paper mill is bound to discontinue it. To express a post-modern sensibility in "Critiques of Pure Abstraction"—an exhibition catalog of post-modern artists who use abstraction as both a critical and expressive vehicle—I decided to approach the cover as a formal exercise of typographic positive and negative space but using an odd, gunmetal-blue, metallic Chromolux stock with fluorescent orange silkscreen ink. Somehow, I was able to get my hands on the stock for comping purposes, but when it came time to print, the stock was no longer available. To create a facsimile of the comp (a post-modern act unto itself), we tried offset printing a metallic blue PMS over a fluorescent PMS. We played with the positive and negative aspect on press and selected a version. The title was silkscreened in white over the completed image—a step that could have been avoided with some knockout type had we not painted the entire cover fluorescent orange first. The orange ink extends over four-inch endflaps on the front and back where it meets chartreuse endpages. They glow against the orange endflaps.

"Hybrid Neutral" was my baptism by fire. As my first big job for Independent Curators Incorporated (ICI), it was axiomatically cursed. The crystallized paper just seemed right for an exhibition full of artists who use wood-grained plastic laminate and Lava Lamps as their medium. Four-inch endflaps with bright yellow endpages were planned to help give the book a bit more structure.

"hybrid neutral"

"after perestroika: kitchenmaids or stateswomen"

The paper manufacturer sent along the ink specifications for offset lithographic printing on this unusual crystallized paper to Studley Press. Studley followed the directions exactly and—you guessed it—the ink never dried. It was decided to try silkscreening the type instead.

A second order of paper was placed, but when it arrived, the texture and luster of the stock were completely different. The manufacturer claimed there was no control over the crystallizing process and that the quality varied greatly from run to run. The client didn't like the new sheet, so we cannibalized stock from the first batch of paper to run the job. The dense color of the silkscreened type looked even better than the offset litho version and had the added bonus of actually drying. However, the sheet was no longer wide enough to accommodate the four-inch endflaps on the front and back. I was intractable about the flaps, so extra rectangles were cut and scored so that I could glue them on by hand. After 1,500 books (3,000 flaps), I learned to be more flexible about the foibles of book production. I should have been grateful just to have type that didn't stick to my fingers.

"After Perestroika: Kitchenmaids or Stateswomen" was a traveling exhibition of works by contemporary Russian artists concerned with feminist issues. When people ask me where I get my ideas, I sometimes quote my ex-wife who responds, "He would get into bed and say, 'I have this project…what should I do?'" I was naturally drawn to the former flag of the Soviet Union, but I credit my ex-wife with the interpretation of the hammer and sickle as a frying pan and spatula. The glossy red cover stock with yellow opaque foil stamp completes the flag reference. To emulate the feeling of the Cyrillic alphabet in English words, I set lowercase *e*s at uppercase height. I resisted reversing the *r*s—it just didn't look right to me.

elizabeth y. akamatsu

appleby studio/nacogdoches, tx

"the embrace"

"devil's seed"

The high pitch of the table saw cutting through thick hard..........fumes and flying orange sparks from grinding steel, and the intense heat from molten metal are some of the physical sensations I experience creating my sculptures. Every part of my body is affected during this process. The creation of my sculpture is a physical act. It requires the lifting of heavy materials and supplies and laborious acts of carving, welding and casting.

This physical process is just one of the aspects that I find attractive in the art of sculpture. Equally compelling is the balancing of formal considerations with content. I pay meticulous attention to the relation of parts, richness of surfaces and fluidity of line. I want my work to be at once beautiful and personal. Through my work I search for answers to questions which concern me. The quest to understand the key to happiness, peace, satisfaction and desire is a universal concern. It is this search for some kind of understanding, however elusive and fleeting, which drives my work.

The Embrace, 1994 (24" × 30" × 19") (61cm × 76.2cm × 48.3cm)

This is a cast bronze sculpture. It is an abstraction of a devil's seed claw, a pod found in West Texas. The pod's average size is four inches. It procreates by shooting out its seeds, which are then blown around by the never-ending West Texas winds. The seeds are also spread by the ability of the claws to grab onto the ankles of pasturing animals such as cattle and horses. Despite its lace-like and linear structure, the pod is nearly indestructible. I found the form of the pod to be

"he sees beauty everywhere"

both sensual and beautiful. I wanted to capture the pods' essence by enlarging the form and emphasizing the claws and tendrils. The piece hangs on a wall at the height of the average man's shoulder and its claw spread is that of the average man's shoulder width. It is very detailed so that the viewer must approach it closely. It pulls the viewer within its grasp with its delicacy, and at the same time it pushes the viewer away by its repulsiveness. Many people find it very frightening yet seductive.

He Sees Beauty Everywhere, 1996; steel, bronze, tar paper, wood, copper (48″ × 4.5″ × 3″) (121.9cm × 11.4cm × 7.6cm)

This piece is made of a steel box with cast bronze thorns and an orange sandwiching tar paper. It addressed my history, especially my heritage as a Japanese–American. It is about my grandfather who was interred in a relocation camp during the Second World War. He passed the time by carving delicate birds out of discarded orange crates. Despite the bleak surroundings of barbed wire barriers and tar paper-covered barracks he saw beauty everywhere, hence the title.

Interconnected, 1994; steel, African slate (32″ × 130″ × 27″) (81.3cm × 330cm × 68.6cm)

"Interconnected" was inspired by Japanese rock gardens. First developed by Zen Buddhist priests during the sixth century, these flat, symbolic environments consist solely of gravel and rock. The gardens feature large rocks placed asymmetrically on a sea of fine white gravel. They are very personal places designed for silence and meditation. In a Japanese rock garden and with my piece it is important that viewers are able to freely interpret what they see. Some people see the form as islands, others as an animal leading her child to safety.

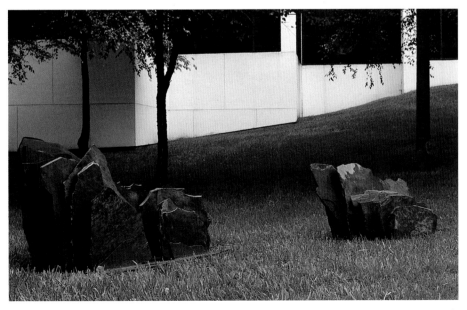

"interconnected"

donna reynolds

racer-reynolds illustration/oakland, ca

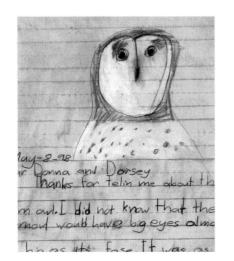

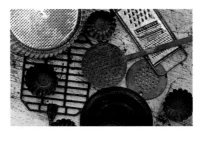

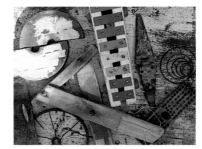

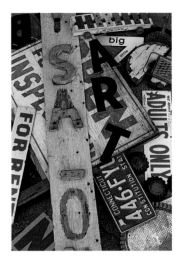

the inspirations

When I find a junked treasure, I might know immediately what I will do with it. The shape of it might remind me of something and beg to be transformed immediately. Or, I might just tuck it away into a growing pile of clutter and rediscover it for a later project.

Sometimes there might be a curious theme going on in my life, and I'll miraculously come across the perfect chunk of something to create a piece that mirrors this current drama.

For example, after a shooting in our urban neighborhood, I discovered an old poster with the headline "Afraid of Gangsters!" This turned into "Gangster Boy"…who wears candy corn for teeth to illustrate the young age of this child gun-toter (and the thousands more like him).

Besides getting inspiration from finding crazy junked objects, I love looking at both children's art and primitive folk art. The brave and innocent simplicities of these creations can just make me want to weep.

As an illustrator of the new century, I realize I "should" be learning how to use the computer that is sitting here collecting dust. But every time I try to sit down and figure out a new program, I am too easily distracted by either a fabulous chunk of junk that is staring at me from across my room or my dogs bugging me for their walk.

Flat Kat

I needed to create a villain for a children's book about some misunderstood rats (*The Bad Rap Rats*). When these two pieces of rusted metal lined up, it was a no-brainer. There was no question what they would become. It feels just fantastic on those odd occasions when an art piece can be born almost without effort!

Real Estate Guy

I couldn't believe it when we bought our first house. The sold sign laid in the side yard for months, and I just kept staring at it in disbelief. So of course it was destined to become art…especially after I found an old beat-up sign at the dump

advertising the name of a real estate agent…perfect for his face.

Bad Dog

I used an old backgammon board for his teeth and a beat-up chair back for his body. His hackles are an old comb. I wanted him to look like a child's drawing of a threatening dog. Lots of kids in my neighborhood are scared to death of dogs. This must be what they all look like to them.

Lady Ouija

This is the same Ouija board I played with as a preteen. I could tell many spooky stories about using that board! I used phone parts with this gal to illustrate the wonderful world of "ghostly" communication. Her halo is an old metal drum lid and her body is sprinkled with "milagros," little charms used to ask for help or protection.

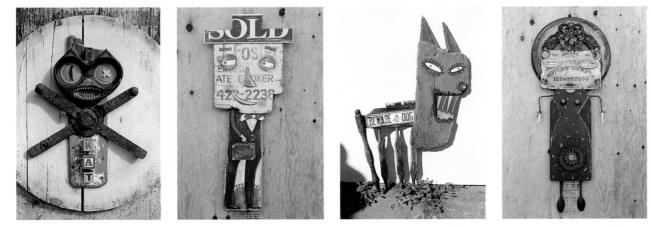

"flat kat" "real estate guy" "bad dog" "lady ouija"

martin holloway

martin holloway graphic design/warren, nj

Creativity is a slippery word.

We can all agree that it involves self-expression—a vision that is personal, rather than derivative; and that the resulting works will elicit responses like: "I wish I had thought of that" or even "I don't get it but I love it!" Recognizing the results of creativity is one thing, but planning how one gets it, and then how to use it to create exciting visual work is quite another. Creativity is resistant to definition, and to teaching. One may convey to others tricks that seem to suggest a creative approach, but each individual must tap methods that are profoundly personal to sustain a creative mode of operation.

Often, the validation of creative expression is in the hands of critics, scholars, fellow artists and designers, and ultimately, history. Certainly the lay audience, which includes all of us not on the elite short list above, is understandably baffled and made suspicious by the coronation of some creative work as brilliant and the dismissal of other work as minor.

Visible Language, A Democratic Art

Creativity in graphic design is less problematic to assess than in the fine arts because the objectives of graphic design are clear. Designers are usually required to solve the communication problems of business, industry and the mass marketplace; fine artists are usually concerned primarily with self-expression. The problems designers deal with are usually externally imposed by a client; the fine artist's problems are usually self-imposed.

The goal of graphic design and the function of typography is to make the client's message persuasive to the audience. This is a given, and is the least that design must accomplish. The vocabulary of graphic design, combining visual and written expression, can be used to give infinite shades of meaning to a message, to express the spirit of an era, or to convey the individual viewpoint of the designer. No visual statement has only one dimension. It is the great challenge of designing with type to use this most utilitarian of visual forms in a way that exceeds the expectations of mere clarity and legibility.

Engaging the Viewer

The common denominator in approaches to designing with type is that all require the interest and involvement of the viewer. This is the first rule of graphic design—one must engage one's audience. The visual power of typography in graphic design is largely its potential for a synergistic effect of written and pictorial meaning. All of us carry a vast store of words, images, colors, historical styles and other visual materials in our subconscious. These are connected to ideas, convictions, emotions. By recognizing this as a powerful arsenal for communication, the designer can realize the full potential of graphic design. Various combinations and juxtapositions of these elements can trigger an unlimited variety of responses in the mind of the viewer.

The most successful designers are those with the best instinct for knowing how people think, combined with a mastery of the visual tools of design. Although engaging the viewer successfully is often manifested through uncomplicated graphics and simple, direct

responses; this result is usually rooted in a more complex process of visual symbols engendering reactions informed by individual life experiences and attitudes. The designer's goal is to tap into the mysteries of human thought and hopefully influence and motivate the viewer toward a particular action or viewpoint.

The Challenge

As Michelangelo freed the statue from the block of marble, a graphic designer discovers a design solution within the problem. This sounds deceptively easy, as though great work results from simply moving through the production steps, but a profound truth lurks in this statement. Great solutions have an innate logic, a rationale evolving out of the designer's unique problem-solving method. In this way, truly creative works are the inevitable result of pursuing a solution to its natural conclusion. The end result of the process is works that have the appearance of being the perfect solution, the only solution.

mary lum
hornell, ny

"leaf stains"

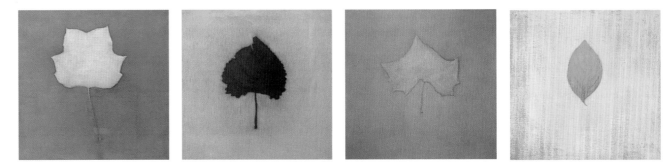

"leaf paintings" *(oil on wood)*

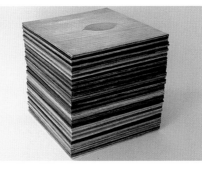

"stack of 40 leaf paintings" *(oil on wood)*

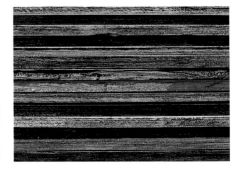

"detail of side of stack of 40 leaf paintings" *(oil on wood)*

The abstract experience of everyday life is the single thing that inspires me the most. Each is different in its details, in what I notice or think about while walking (or driving, or riding) from here to there. Things are changing all the time. I find great pleasure in the commonplace systems of daily activity. Reading is an important part of my day, not necessarily in time spent, but in how I am influenced by it. I read everything, newspapers, novels, magazines, the comics, nonfiction. Reading inspires me, both directly and in oblique ways, to think differently about my observations. For me, ideas come from noticing things, then considering them through a broad range of experience.

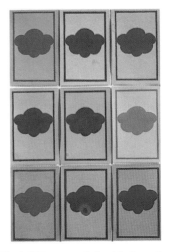

"288 paintings of a french book cover" "stack of 288 paintings of a french book cover" *(gouache on paper)* "detail of 288 paintings of a french book cover"

piero fenci

appleby studio/nacogdoches, tx

Intimate scale, the history of use, the tactile qualities of touching and lifting, and, above all, the interaction of surface and form are central concerns in my work. I have developed a deep attachment to many types of functional objects. They include Etruscan pottery, pre-Columbian architecture, Japanese armor of the Muromachi period, Shaker hatboxes and tinware, and traditional Origami. I take these archetypes, filter them through my psyche, and intuitively connect them. My work, therefore, constitutes loosely rendered reinventions of objects with which I have fallen in love; they are my attempt to build a family tree of spiritual ancestors, a heritage of my own passions.

Origami Handbag (18" × 15" × 10") (45.7cm × 38.1cm × 25.4cm)

The Origami Handbag was influenced by three loves—Shaker baskets, Japanese Origami and the fashion industry. I lived in upstate New York for several years, and made a study of Shaker settlements. Shaker woodwork and tinware influenced the manner in which I constructed my vessels. The spirit of the handle of this piece echoes that of the lovely arching handles of Shaker baskets. The zigzag moves of the sides of the piece are reminiscent of Origami, the Japanese art of paper sculpture. The finished object as a whole appears to be a handbag. When my wife drags me to the big city to shop, I find myself staring at the purses and handbags in the stores, perhaps because they are vessels of the utmost elegance and sophistication.

Sakai Shaker Hatbox (10" × 16" × 14") (25.4cm × 40.6cm × 35.6cm)

The Sakai Shaker Hatbox was influenced by a wooden hatbox I saw in Hancock Village, a Shaker settlement which is now a museum in New York; a poster of Japanese crests and castles sent to my wife from Japan; and a Picasso pitcher made in southern France. The Sakai crest on the poster caught my eye—the shape was like a four-leafed clover. Something clicked in my head, and a connection was made between the essentially round Shaker hatboxes I was making and this new cloverleaf configuration. Picasso painted a decoration on the side of his pitcher of a pitcher, the same idea of Shakespeare's play with a play. I picked up on that move with the way I decorated the piece, repeating the cloverleaf pattern all over its walls.

Japanese Pillow with Goose Lid (10" × 16" × 15") (25.4cm × 40.6cm × 38.1cm)

The Japanese Pillow with Goose Lid was influenced by a Japanese clay pillow I saw in the Metropolitan Museum, my travels in Guatemala studying Mayan archaeology, and my interest in ornithology. Japanese women used ceramic pillows which cradled their necks so their hair would not be disturbed as they slept. The intimacy and the beauty of the small pillow in the Metropolitan made a lasting impression. The basic form of the vessel with its concave swoop comes directly from that influence. The inside of the vessel is reminiscent of the architecture of the pyramids of Tikal, the magnificent Mayan ruin in the Peten region of Guatemala, where the thickness of the walls protect small, claustrophobic spaces deep within. The lid of the vessel with the two goose head shapes is directly influenced by my interest in birds and the ability of Mayan craftsmen to incorporate images of animals in their pottery, combining man-made structures with organic references in a manner which was not self-conscious.

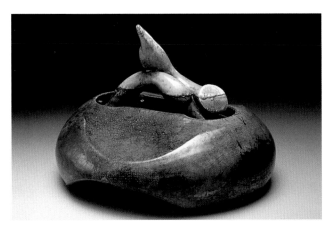

"japanese pillow with goose lid"

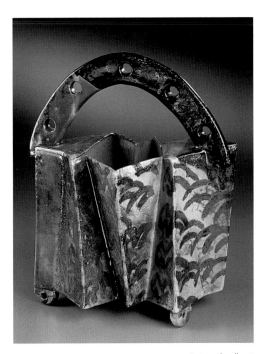

"origami handbag"

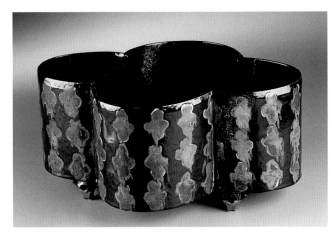

"sakai shaker hatbox"

greg leshé

greg leshé photography/south orange, nj

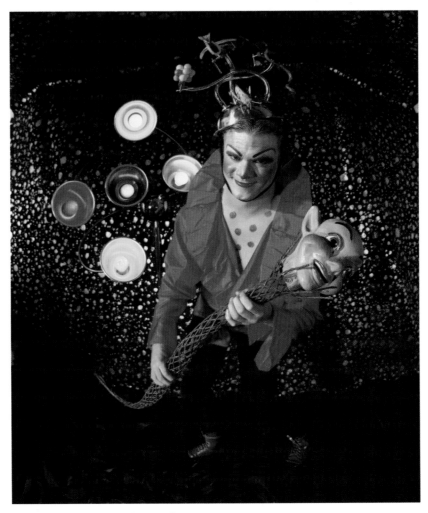

"the joker" *(hair and makeup by Alan Rowe Kelly)*

flor yalong and the philippino string ensemble

ralph bartone, entertainer

I specialize in assignment photography and visualizing people. Every time I photograph an individual or a group, I'm inspired, and try to learn something about humanity, about myself and about the possibilities of art making. I approach every assignment as a unique opportunity to say something new about people and contemporary experience. I am truly grateful that people allow me to work with them to share in creating photographs.

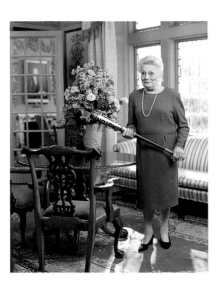

anna daube freund

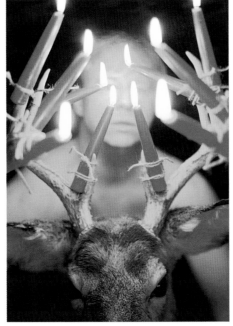

"buck dreams," *self-portrait*

domo band

petrula vrontikis

vrontikis design office/los angeles, ca

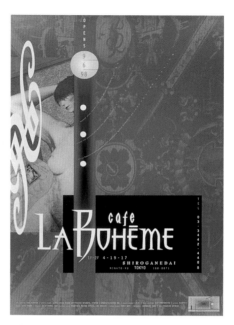

cafe la boheme poster and invitation

These designs, to announce the opening of Cafe La Boheme, are a reflection of the eclectic nature of the restaurant. This restaurant, located in Tokyo, is the most recent addition to the twenty-eight restaurants created by Kozo Hasegawa, president of Global-Dining, Inc. The background pattern is from a photograph of a Florentine ceiling I shot in the Uffizi Gallery. The figures are from a contemporary French painter; the color and form are a Japanese/Chinese

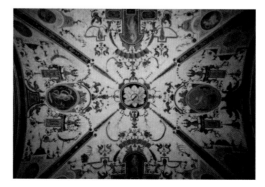

cafe la boheme, *uffizi gallery ceiling*

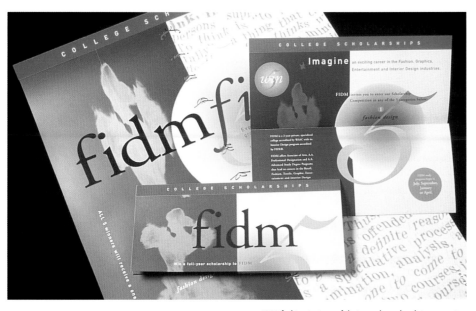

1998 fashion institute of design and merchandising campaign

mix. The type forms reflect a Gothic influence. All of these attributes uniquely combine in the overall restaurant graphics, interior and cuisine.

This 1998 Fashion Institute of Design and Merchandising Campaign announces a contest to apply for five scholarships being offered to high school students. The dancing figure on the left and the dancing typography on the right represent imagination, creativity and exploration of ideas.

"I found the original image for 'dancing type' in an antique handbook that my grandmother owned on etiquette in speech and writing. *S.O.S Slips of Speech* was among my grandmother's belongings (she arrived in the U.S. from Greece as a little girl). When considering the FIDM scholarship poster, I saw a section on the nuances of the words THINK, IMAGINE and JUDGE. I thought it was a perfect match. While photocopying it, I moved the book page to create waves. It was the perfect counterpoint to the dancing lady image."

fidm inspiration

copyright notices

index